NORTH OXFORDSHIRE COTSWOLDS

THROUGH TIME

Stanley C. Jenkins

AMBERLEY PUBLISHING

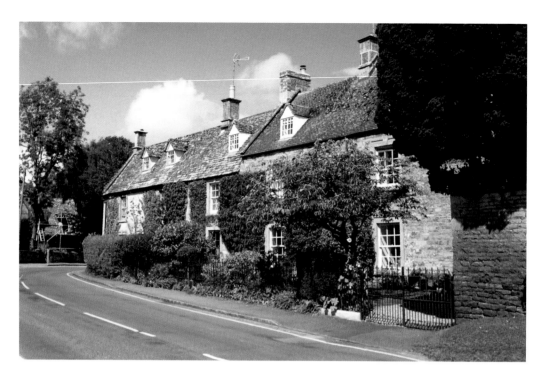

Kingham: Cotswold Buildings
Cotswold stone houses in Church Street, Kingham.

First published 2013

Amberley Publishing
The Hill, Stroud, Gloucestershire, GL5 4EP
www.amberley-books.com

Copyright © Stanley C. Jenkins, 2013

The right of Stanley C. Jenkins to be identified as the
Author of this work has been asserted in accordance with
the Copyrights, Designs and Patents Act 1988.

ISBN 978 1 4456 1280 5 (print)
ISBN 978 1 4456 1302 4 (ebook)

British Library Cataloguing in Publication Data.
A catalogue record for this book is available from the
British Library.

Typesetting by Amberley Publishing.
Printed in Great Britain.

Introduction

The county of Oxford came into existence during the tenth century. Oxford itself was laid out as one of the fortified 'burghs' that King Alfred and his descendants employed in their campaign against the Danes, while the surrounding territory became the newly created county of Oxfordshire. The original county was irregularly shaped, with a bulbous 'head' in the north and a projecting 'tail' in the south-east – although the 'tail' portion was considerably augmented as a result of boundary changes in 1974, when the Vale of White Horse district was transferred from Berkshire to Oxfordshire.

The scenery within the Oxfordshire area is dictated by the underlying geology, which – generally speaking – consists of a limestone plateau in the north and a chalk escarpment in the south. The limestone and chalk districts are separated by an intervening belt of low-lying Oxford Clay, which crosses the county from west to east. The limestone area contains two sections. The southern part is composed of honey-grey Oolitic limestone but, as one travels north-eastwards, the Oolitic limestone is replaced by a plateau of Middle Lias or Marlstone – a sandy ferruginous rust-brown limestone often referred to as 'ironstone'.

The area we have defined as 'North Oxfordshire' is a roughly triangular district, delineated by the Gloucestershire and Northamptonshire borders in the north-west and north-east. In the south, however, the boundaries are less clearly defined although, generally speaking, the Wychwood Forest area forms a natural boundary.

Although North Oxfordshire is, in many ways, a typical 'Cotswold' area, there are subtle differences between the Oolitic limestone district and the ironstone country further north. The honey-grey Oolitic villages have a distinct 'West Country' atmosphere, whereas the brown ironstone villages seem to have a greater affinity with the south Midlands – a reflection, perhaps, of the historic tensions that once existed between the rival kingdoms of Wessex and Mercia?

In the Middle Ages, Oxfordshire and the Cotswold area became one of the most prosperous parts of England, and by 1334 Oxford was the eighth richest town in England in terms of its tax quota. This enviable wealth was based mainly on agriculture, and especially wool production, which was already becoming a major activity throughout the Cotswold region.

Oxfordshire played a major part in the first Civil War, beginning on 22 August 1642. The first large battle, which took place at Edge Hill near Banbury on 23 October 1642, was inconclusive, but it enabled King Charles to set up his wartime capital in Oxford, where the university (if not the town) supported his cause. The sympathies of Oxfordshire as a whole were probably with the Parliament. Many Parliamentary leaders, including John Hampden (1594–1643), Speaker William Lenthal (1591–1662) and Lord Saye & Sele (1582–1662) resided within the county, or had properties in the area. Lord Saye & Sele, for example, lived in Broughton Castle, which surrendered to the Royalists in 1642 (*see pp. 20–22*). Further battles were fought at Chalgrove in June 1642, and at Cropredy in 1644 (*see pp. 33–35*).

Trade was disrupted by the conflict, and the countryside was plagued by Royalist troops who scoured the countryside demanding food, taxes and the right to sequester 'rebel' property. In economic terms, the North Oxfordshire region suffered as a result of the conflict, and Banbury sustained major damage. In 1646, for example, a petition to the House of Lords claimed that 'one halfe of the Towne' had been 'burned down'. Indeed, it could be argued that parts of the Cotswolds never fully recovered from the trauma of the Civil Wars.

Little new building took place after 1700, and in the following century many of the remote Cotswold towns and villages entered a period of decline. By the start of the Victorian period, the Cotswolds had become something of a backwater. There were, nevertheless, several towns of varying importance – notably Banbury and smaller market towns such as Witney and Chipping Norton – several of which managed to retain their links with the traditional Cotswold woollen industry.

NB – Banbury and Chipping Norton are examined in greater detail in the companion volumes *Banbury Through Time* by Jacqueline Cameron (Amberley, 2011) and *Chipping Norton Through Time* by The Chipping Norton Local History Society (Amberley, 2009), while most of the villages between the Evenlode Valley and the Thames are covered in *The West Oxfordshire Cotswolds Through Time.*

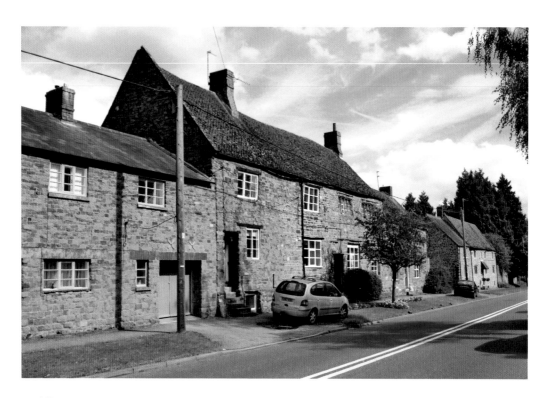

Deddington: Ironstone Buildings
A rust-brown ironstone house in Deddington. Although superficially similar to Cotswold houses, these characteristic brownstone buildings tend to be of simpler construction than their Cotswold counterparts, with fewer gables, steeper roof profiles and smaller windows.

Adderbury: St Mary's Church

Adderbury, $3\frac{1}{2}$ miles to the south of Banbury, was formerly a market town of some importance, although it is now regarded merely as a village. The Domesday Book suggests that in 1086 'Edburgberie', which belonged to King William and the Bishop of Winchester, had a population of around 250. The village is divided into Adderbury East and Adderbury West by the Sor Brook – the parish church being in Adderbury East – which is the largest of the two settlements.

St Mary's church is a cruciform structure, incorporating a nave, aisles, transepts, porches and a west tower with an octagonal spire and corner pinnacles. The chancel was rebuilt around 1412, the mason being Richard Winchcombe who also built the Divinity School at Oxford. A monument within the church commemorates the Revd Dr William Oldys (c. 1590–1645), a staunch supporter of King Charles I during the Civil War who was shot dead by a Parliamentarian soldier (allegedly one of his own parishioners) in September 1645.

Adderbury's most famous resident was perhaps John Wilmot (1647–80), the dissolute 2nd Earl of Rochester who, in 1665, kidnapped Elizabeth Malet, a beautiful heiress, and subsequently married her. Their former home, Adderbury House, which lies to the east of the green, was partially demolished in 1808.

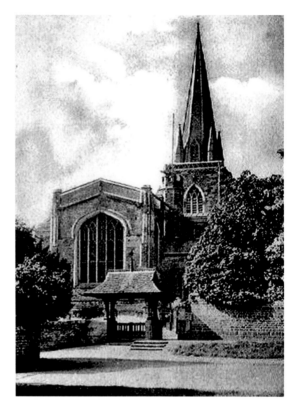

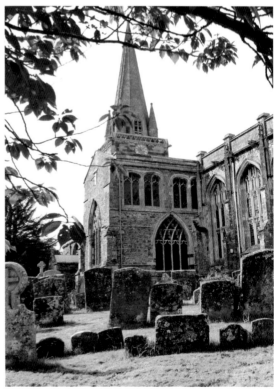

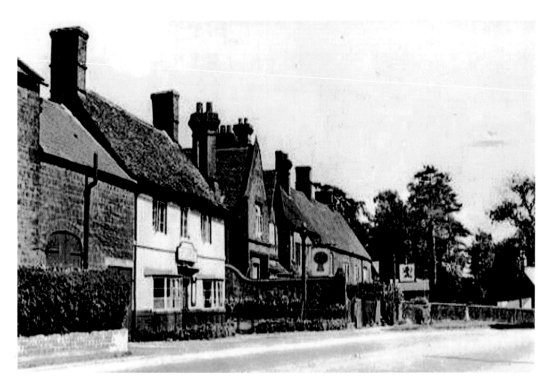

Adderbury: Oxford Road and The Wheatsheaf

Adderbury contains many old buildings, including these examples on the east side of the A4260 Oxford Road. This busy road is flanked on its west side by a roughly triangular green, which is pleasantly shaded by trees. The picture above dates from around 1948, while the colour view was taken over sixty years later. The Wheatsheaf pub, seen on the left in the earlier view, is now a private house; it is of brick construction, and probably dates from the eighteenth century.

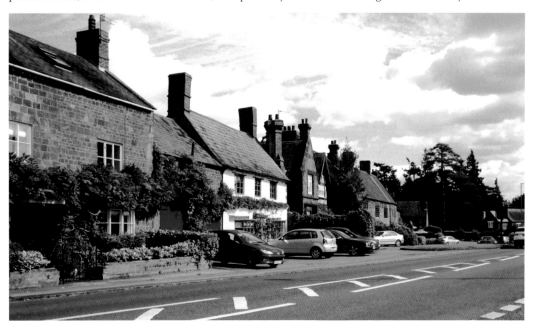

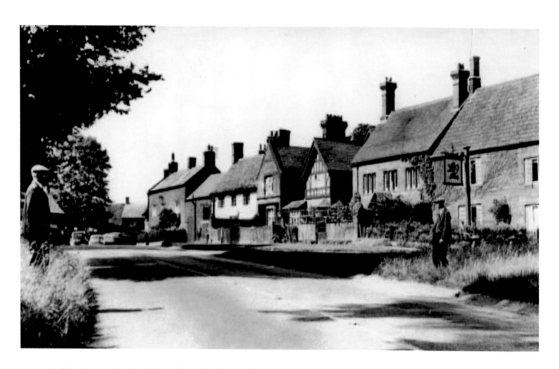

Adderbury: Oxford Road and The Red Lion

Another view showing houses on the east side of Oxford Road, with the still-extant Red Lion pub featuring prominently on the right-hand side of the picture. Most of the houses and cottages in Adderbury are built of the local rust-brown ironstone, and many of their window and door apertures have wooden lintels that bear the weight of the stonework above. The roofs, which in most cases would originally have been thatched, have a noticeably steep pitch, at an angle of around 58–60 degrees.

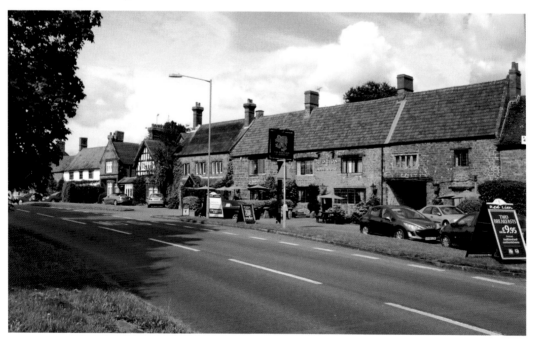

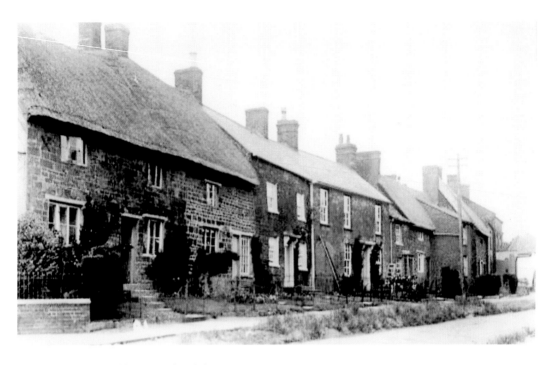

Adderbury: Old Houses in High Street

Two contrasting scenes showing a group of old ironstone houses on the north side of the High Street. The postcard above dates from around the 1920s, while the colour photograph was taken in August 2012. Some changes have clearly taken place during the intervening years, notably the demolition of one of the thatched cottages that can be seen to the left in the upper view.

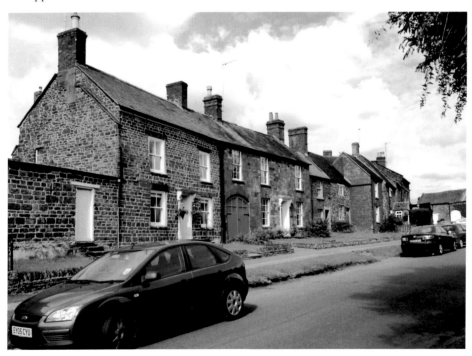

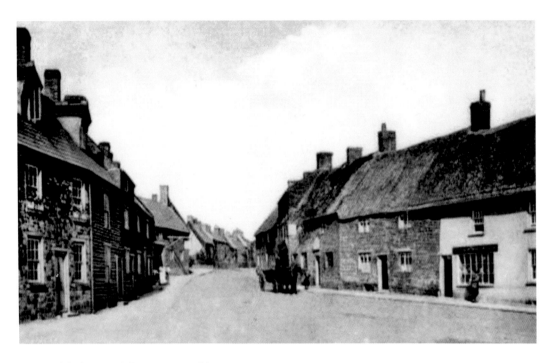

Adderbury: High Street, Looking East

This Edwardian postcard shows the High Street, looking east towards the green, with a row of thatched cottages visible to the right. The lower photograph was taken from the same vantage point in August 2012. Several of the houses have received new window frames, and the shop that can be seen to the right of the earlier photograph is now an ordinary house. The still-extant Bell Inn can be discerned in the centre of both photographs.

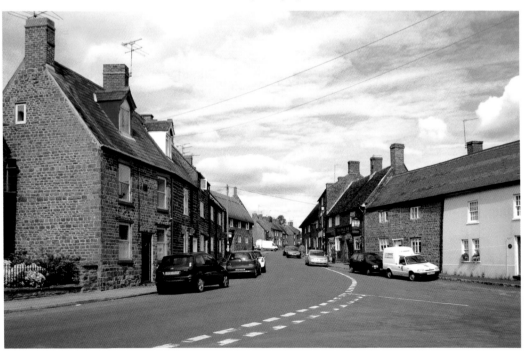

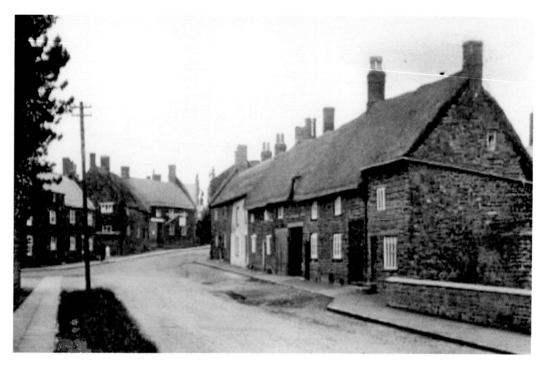

Adderbury: High Street from Mill Lane

Another glimpse of Adderbury High Street, this time looking north-eastwards from Mill Lane. The above view dates from around 1930, whereas the colour photograph was taken in 2012. A number of chimney stacks appear to have been modified or removed but, in general, little has changed in this quiet side street, which provides a means of access to the parish church.

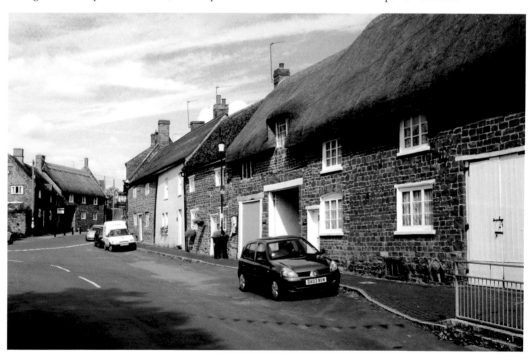

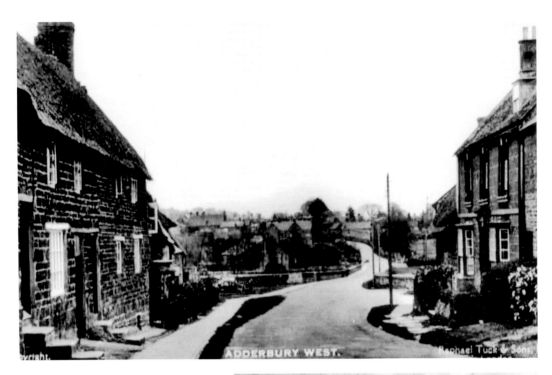

Adderbury: Church Lane and Cross Hill Road

Some further examples of the local building style. The postcard above shows some old buildings in Cross Hill Road, Adderbury West, while the recent photograph provides a glimpse of Church Lane. The thatched cottage visible to the left in the lower picture has a steep roof pitch of about 60 degrees, which is fairly typical of the North Oxfordshire district. When these old cottages were re-roofed with slates, their roof pitches were invariably reduced.

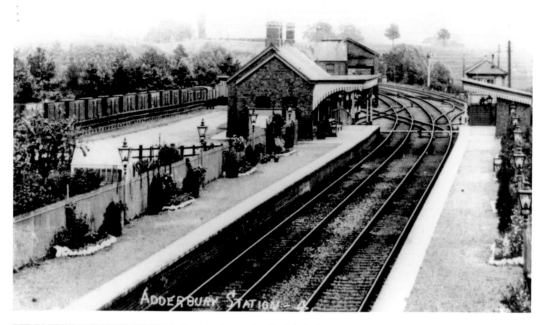

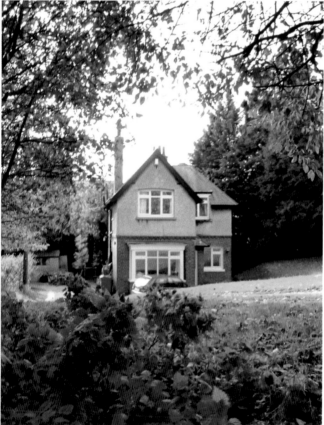

Adderbury:
The Railway Station
Situated on the Banbury & Cheltenham Direct Line, Adderbury station was opened on 16 April 1887. The track layout consisted of up and down platforms and a crossing loop. The station building and goods yard were on the up side, while a waiting shelter was provided on the down platform. Passenger services were withdrawn in 1951 and the station was closed to all traffic in 1969. The site of the station is now an industrial estate, although the stationmaster's house (*left*) has survived.

Banbury: The Famous Cross

With a population of 10,012 in 1901, rising to 13,953 in 1931 and 43,867 in 2001, Banbury is the largest town in north Oxfordshire. It is also a place of considerable antiquity. Its name derives from the Saxon 'Bana', which means a place of murder or battle, while the Domesday Book records that in 1086 'Banesberie' was held by the Bishop of Lincoln. Notwithstanding its lengthy history, much of the town is of Victorian origin – including the famous Banbury Cross, which was erected in 1859 in imitation of a medieval cross torn down in 1612. The colour postcard (*above*) was posted in 1919, while the lower photograph shows the famous cross during the 1950s.

Banbury once boasted several interesting old buildings, including a castle and a medieval parish church, but most of these historic structures were swept away during the seventeenth and eighteenth centuries. The castle was dismantled after the Civil War, and the church was blown up with gunpowder in 1790 to avoid the expense of restoring it. Its replacement was a classical structure with a cylindrical tower, which can be seen on the extreme right of the upper postcard.

Apart from its nursery rhyme cross, Banbury was famous for its 'Banbury Cakes', which were aptly described in Edwardian editions of F. G. Brabant's *Little Guide to Oxfordshire* (1906) as 'a sort of compromise between a tart and a mince-pie'. These distinctive cakes were, according to the *Little Guide*, 'still industriously hawked at the neighbouring railway stations' during the early years of the twentieth century.

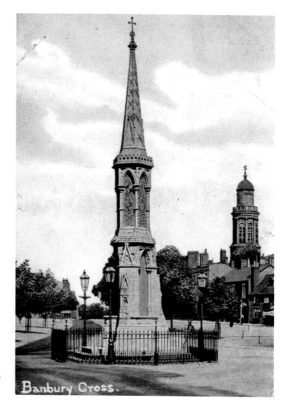

Banbury Cross.

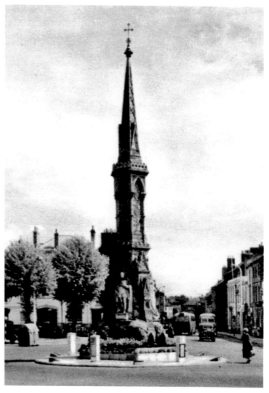

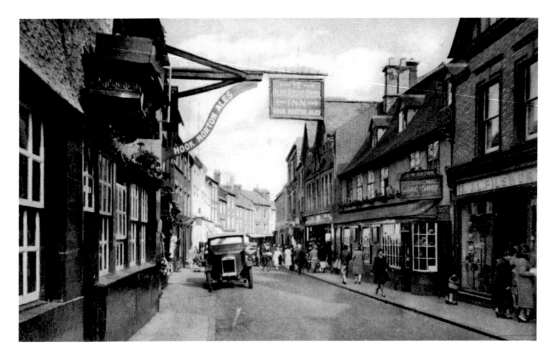

Banbury: Parsons Street
Notwithstanding the destruction of its church and castle, Banbury still contains some picturesque old buildings, one of these being the sixteenth-century Reindeer Inn, which can be seen on the extreme left in this postcard view of Parsons Street from around 1930. The colour photograph, taken by Robbie Robinson in November 2012, reveals that this historic structure has remained intact. The wooden gates at the entrance are dated 1570, while a gabled room at the rear of the inn is dated 1624.

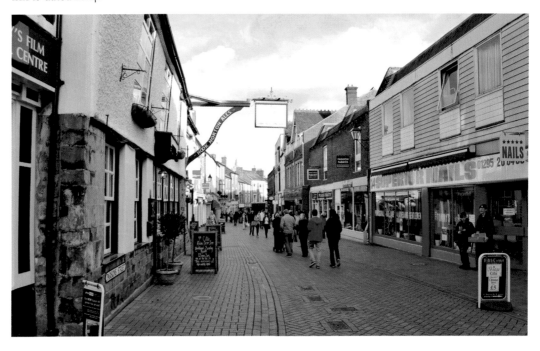

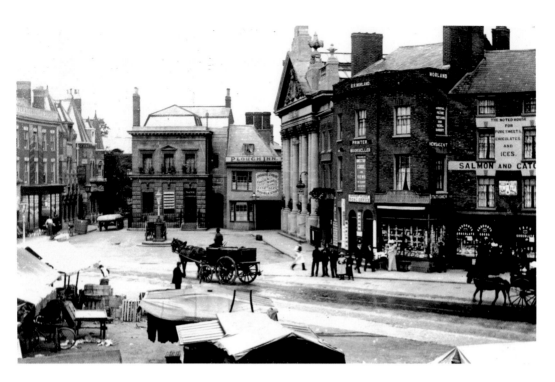

Banbury: Cornhill & Market Place

(*Above*) An Edwardian postcard showing Cornhill – a small square projecting from the Market Place. A number of interesting buildings can be seen, including the Plough Inn and the Corn Exchange, which was designed by William Hill (1827–89) of Leeds and built in 1857. (*Below*) This recent photograph indicates that various changes have taken place – the impressive façade of the former Corn Exchange, with its paired Corinthian columns and lofty pediment, is now the entrance to the Castle Quay shopping centre.

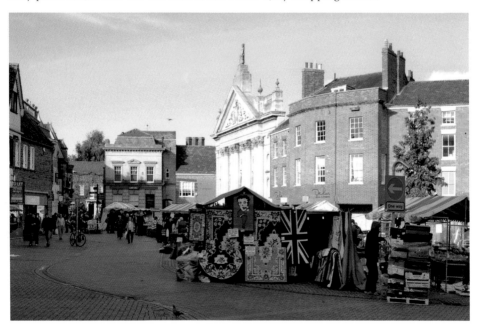

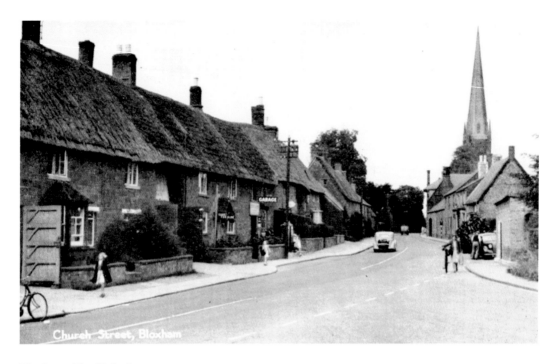

Bloxham: The Main Street

Bloxham, like Adderbury, is a small town that has been relegated to 'village' status. At the time of the Domesday survey in 1086, 'Blochesham' was a royal manor containing no less than six mills, 'rendering £56 4d'. The picture above shows part of the main street, looking north towards Banbury, probably around 1951, while the colour photograph was taken over sixty years later in 2012. The once-predominant thatched roofs have now been replaced by tiled roofs.

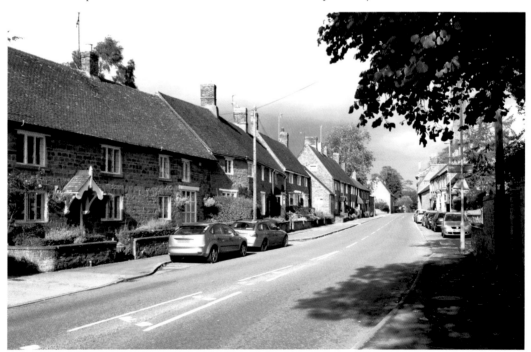

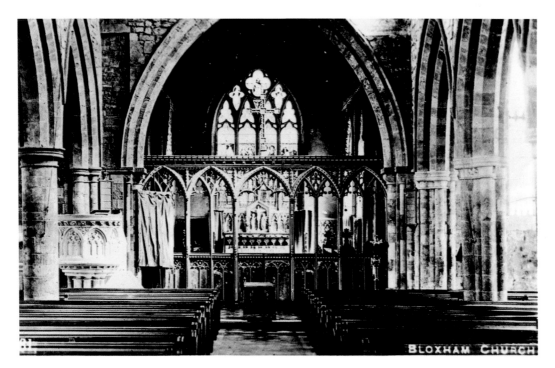

Bloxham: The Church of St Mary

Although Bloxham is full of attractive, ironstone houses and cottages, its greatest architectural glory is its medieval parish church, which rivals that at Adderbury in terms of architectural splendour. It consists of a nave, aisles, transepts, a chancel and two porches, together with a slender fourteenth-century tower and spire that rises 198 feet above the village street. The upper view, from an old postcard posted in September 1913, shows the interior of the church, looking east towards the altar, while the exterior view, showing the tower from the High Street, was taken in October 2012.

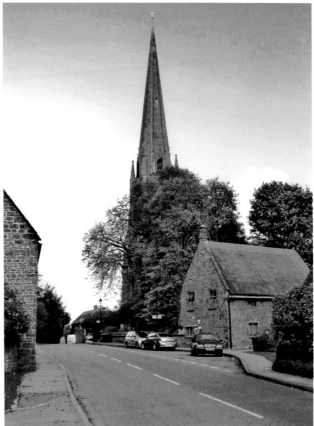

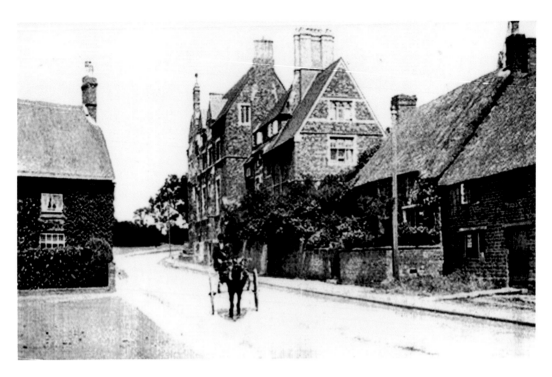

Bloxham: The School

All Saints' School, which dominates the northern end of the village, was founded by the Revd John Hewett in 1854, and refounded by the Revd Philip Egerton in 1859. Many of its Victorian Gothic buildings were designed by the architect George Edmund Street (1824–81), a former pupil of Sir Gilbert Scott. The school was conveyed to the provost and fellows of Lancing College in 1898. The view above shows the three-storey library block around 1912, while the view below was taken in 2012.

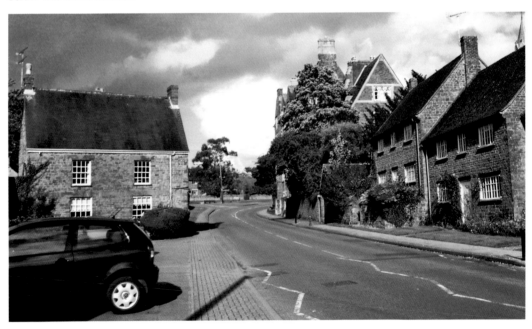

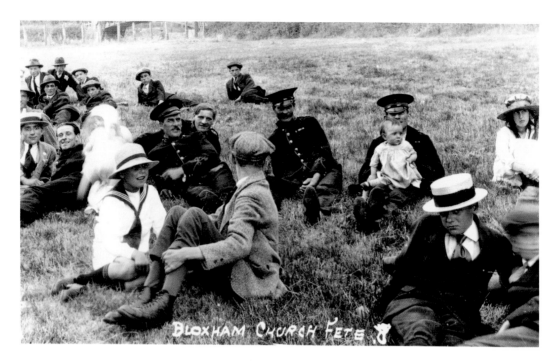

Bloxham: The Banbury & Cheltenham Direct Railway

This old postcard, captioned 'Bloxham Church Fete', shows a group of Edwardians relaxing in fields beside the Banbury & Cheltenham railway line, which can be glimpsed in the background. The gentlemen in military-style uniforms are probably members of a local band (although some of them appear to be wearing Boer War medal ribbons).

The nearby Bloxham station (*right*) was very similar to neighbouring Adderbury. Its track layout incorporated up and down platforms on either side of a crossing loop. The station building and two-siding goods yard were on the up side, and there was a small waiting shelter on the down platform. The slightly curved up and down platforms were linked by barrow crossings, and the A361 road was carried across the line on a skew girder bridge at the east end of the station. The site is now occupied by houses and a playing field.

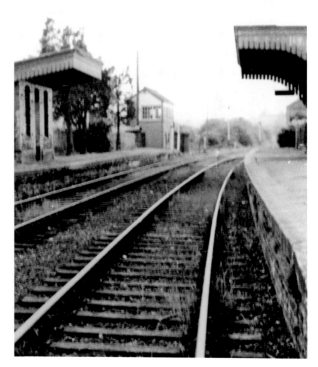

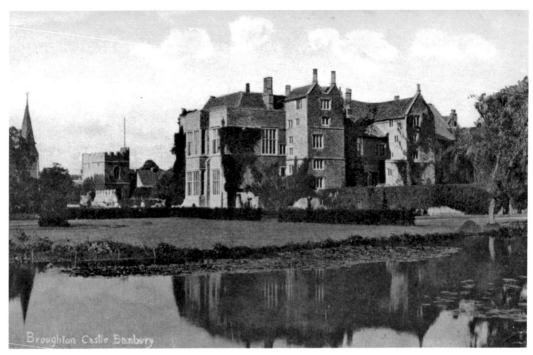

Broughton Castle Banbury

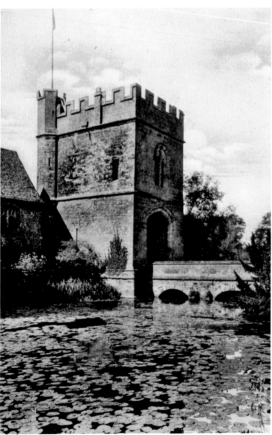

Broughton Castle: The Gatehouse and South Front

At the start of the Civil War, Broughton Castle, the ancestral home of the Fiennes family, was held for Parliament by William Fiennes, (1582–1662), also known as Lord Seye & Sele, a leading opponent of King Charles I. However, the castle was surrendered to the Royalists after the Battle of Edge Hill – its defences having been largely abandoned during the Tudor period when earlier members of the Fiennes family had converted the building into a domestic house.

The picture to the left, dating from the 1920s, shows the fourteenth-century gatehouse, which was retained as an ornamental feature when the castle was 'demilitarised', together with the moat and fragments of the defensive walls. The picture above, from an Edwardian colour-tinted postcard, shows the southwards-facing façade, which was the 'back' of the Tudor mansion – its most prominent features being the two massive stair towers.

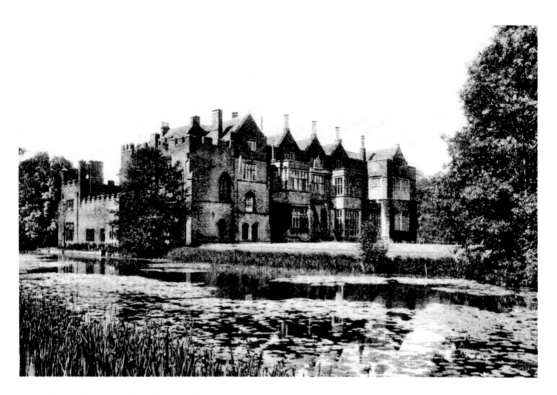

Broughton Castle: The North Front

(*Above*) The north frontage, with its symmetrical façade, was clearly designed as the 'front' of the remodelled house, with two large bay windows and projecting wings on both sides – the east wing is of medieval origin, whereas the west wing was added during the Tudor period to create a balanced appearance. This photograph probably dates from the 1920s. (*Below*) A recent view of the castle, which has remained in the hands of the Fiennes family.

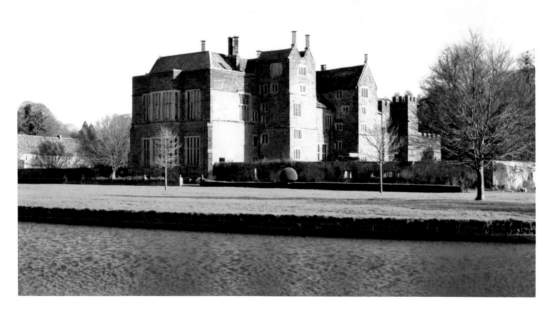

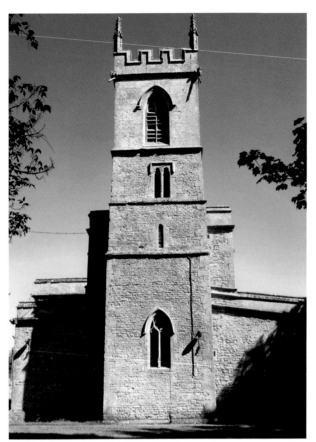

Chadlington: Chapel Road and St Nicholas Church

Chadlington, a scattered village situated on rising land on the north side of the River Evenlode, consists of Eastend and Westend, together with the outlying hamlets of Greenend, Brookend and Mill End. (*Left*) Perhaps confusingly, the parish church dedicated to St Nicholas, is situated in Chapel Road, rather than Church Road! It was rebuilt during the thirteenth century; the nave and aisles are in Early English style, whereas the lofty clerestory dates from the Perpendicular period. The architectural details of the impressive tower suggest that it was constructed during the fourteenth century. (*Below*) These old Cotswold stone houses are sited opposite the parish church on the north side of Chapel Road. The churchyard wall is visible on the extreme right.

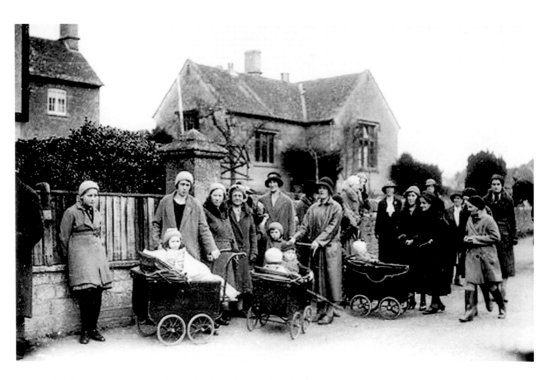

Chadlington: The Junction of Church Road and Chapel Road

These two photographs are looking eastwards along Chapel Road from the junction with Church Road. The picture above shows a group of villagers in front of the village school around 1930, while the picture below was taken in September 2012 from a position about 15 yards further to the east.

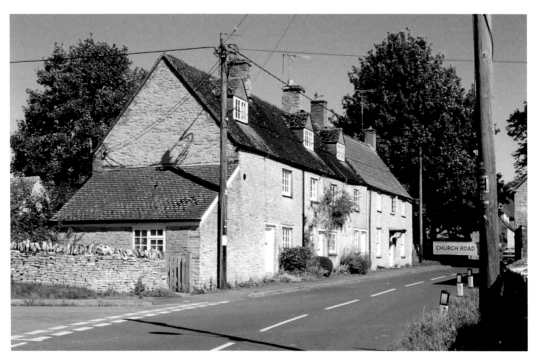

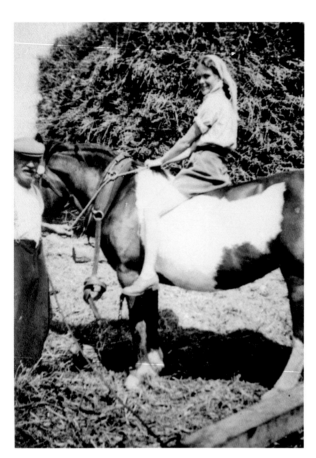

Chadlington: Mill End

The upper view shows an unidentified member of the Women's Land Army relaxing on a farm in the Chadlington area during the Second World War. The Land Army was a civilian organisation that provided additional help for farmers during the two World Wars; by 1943 it had around 80,000 members. The lower view, taken some forty years earlier, provides a glimpse of Mill End, with its cottages and farm buildings, during the early years of the twentieth century.

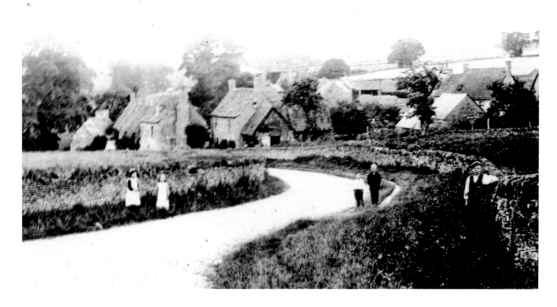

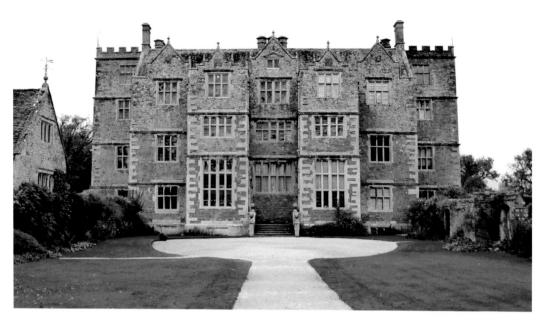

Chastleton House

Chastleton was originally owned by Robert Catesby, who later became a leader of the Gunpowder Plot. In 1602 the estate was purchased by Walter Jones, a wealthy merchant who had made his fortune in the Witney wool industry. The house, completed around 1612, is a tangible reminder of the great rebuilding that took place in the Tudor and Stuart periods. The building features a symmetrical façade of five gables, with crenellated stair towers on each side. The architectural style is similar to other Jacobean mansions such as Burton Agnes Hall.

In 1651, Arthur Jones, the grandson of Walter, was hidden in a secret chamber within the house after escaping from the Battle of Worcester. The upper view shows the main façade in November 2012, while the photograph on the right provides a glimpse of the building from the roadway; the sepia inset shows the house around 1912.

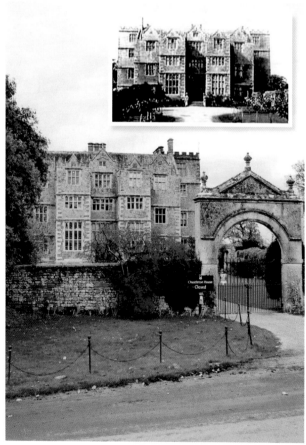

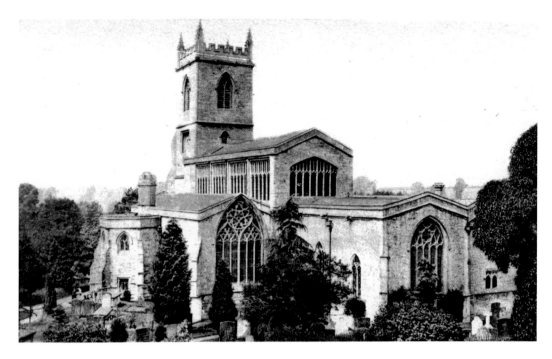

Chipping Norton: Church

Chipping Norton is situated in an elevated position about 700 feet above sea level, and in winter it can be a surprisingly bleak place. The name of the town means 'North Market', 'Chipping' being an old English word for market. (*Above*) This Edwardian colour-tinted postcard shows St Mary's church, which is one of the finest in the county; it features a tall clerestory and a curious hexagonal porch. (*Below*) A recent view of Market Street, looking eastwards.

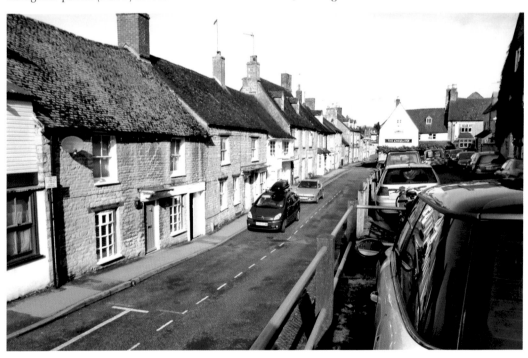

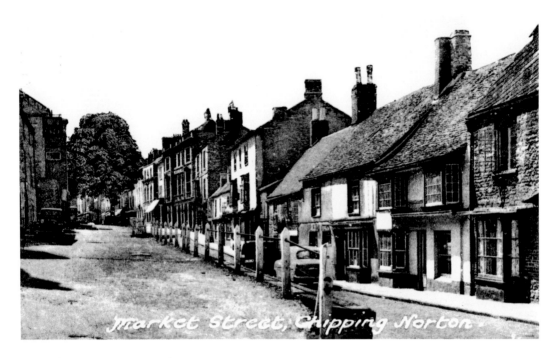

Chipping Norton: Market Street

The picture above shows part of Market Street, looking westwards during the 1950s, while the colour photograph was taken from a similar vantage point in October 2012. Some of the buildings have lost their external plaster rendering but, otherwise, the most noticeable change has been the vast increase in the number of motor vehicles that clog the narrow streets and create major parking problems.

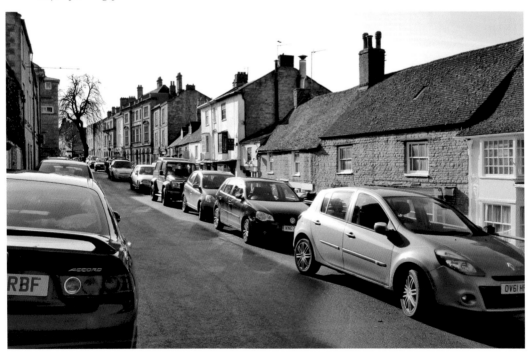

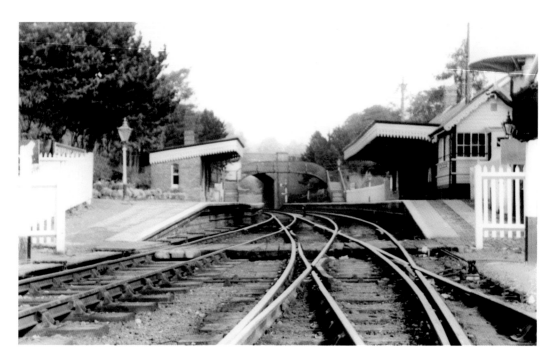

Chipping Norton: The Railway Station

Chipping Norton station was opened in 1855, the first station being the terminus of a
4½-mile branch from Kingham. However, the line was extended eastwards to Kings Sutton
in 1887, and a new station was opened at Chipping Norton, while the old terminus became
part of an enlarged goods yard. The new station had two platforms on either side of a
crossing loop, and the main station building was on the up side. It was closed in 1962 and
the site is now an industrial estate, as seen below.

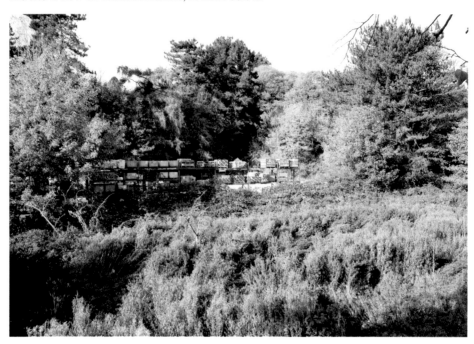

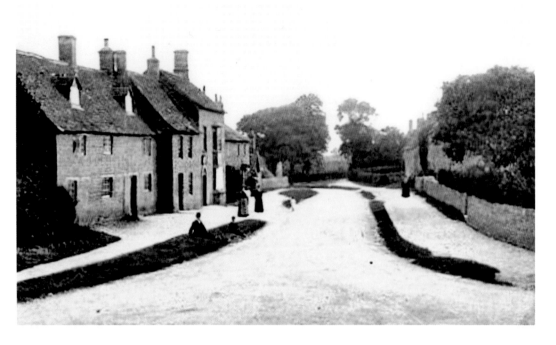

Churchill: Two Famous Men

Situated between Kingham and Chipping Norton, Churchill was the birthplace of Warren Hastings (1732–1818), the first Governor-General of India, who upheld the prestige of the British Empire at the time of the disastrous American War of Independence. This tiny village was also the birthplace of William Smith (1769–1839), the 'Father of British Geology', who made the first geological maps and introduced many of the names by which we know the various rock strata. The pictures show cottages in Junction Road, around 1912, and in 2012.

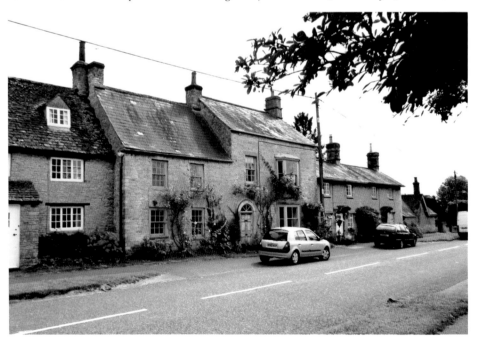

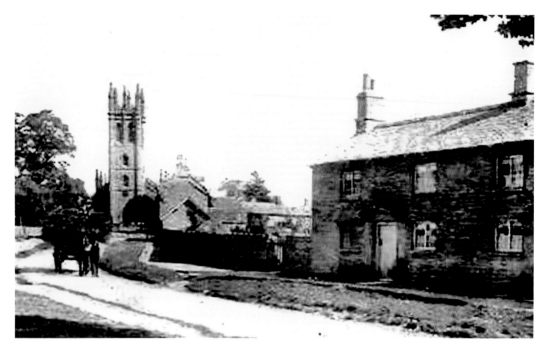

Churchill: All Saints Church

All Saints church was rebuilt on a new site in 1826, the original church in Hastings Hill lane being partially demolished, leaving its chancel as a mortuary chapel. The replacement church, paid for by James Langston, the local squire, has a spacious interior with a hammer beam roof copied from that at Christ Church College, Oxford. The postcard above, from around 1912, shows the church from Junction Road, while the colour view below was taken in 2012. The tower was based on the tower at Magdalen College, Oxford.

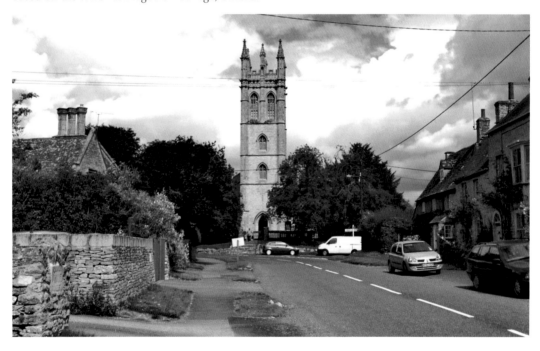

Churchill: The Birthplace of Warren Hastings

The picture to the right is a recent view of Hastings Hill, looking north-west. In 1906 the Great Western Railway (GWR) opened a halt at the bottom of Hastings Hill and, although this new facility was less than half a mile from Churchill, 'Sarsden Halt' derived its name from nearby Sarsden House – the home of the Langstons, who owned most of the surrounding land.

The photograph below provides a detailed view of a pair of late seventeenth-century houses at the top of Hastings Hill, which are known as Warren Hastings House and Hastings Hill House. The building on the right-hand side bears a memorial plaque with the words 'Warren Hastings was born in this house Dec 6 1732 died Aug 22 1818'.

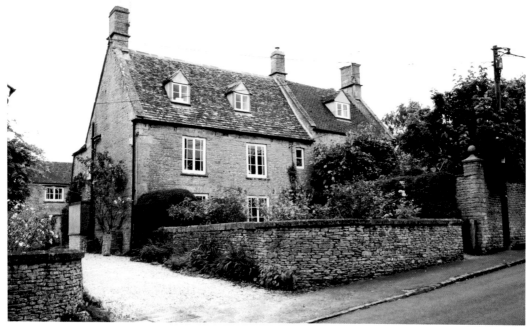

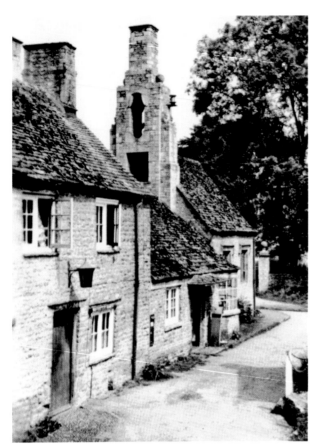

Cornwell

Like Churchill, Cornwell is a Cotswold-style village with a church, a manor house and many old, picturesque houses. It is situated in an elevated position to the north of Kingham. The village was rebuilt during the 1930s by the architect Sir Bertram Clough Williams-Ellis (1883–1978), the designer of Port Merion in North Wales and, as might be expected, some of its buildings are mildly eccentric in appearance. One of the strangest is the former village hall (now the estate office), which boasts a curious tower. (*Left*) A corner of the village, probably photographed during the 1930s, showing the village hall. (*Below*) A more recent view taken in November 2012.

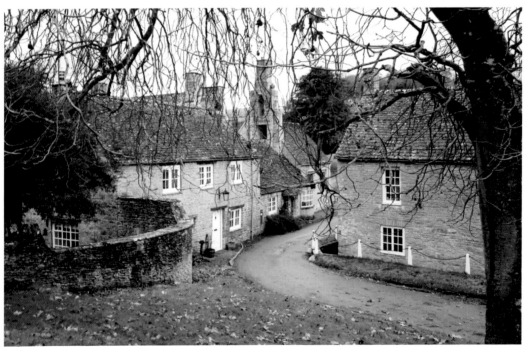

Cropredy: The Battle of Cropredy Bridge

Cropredy, the site of a famous Civil War battle, is situated on the River Cherwell, about 5 miles to the north of Banbury. In June 1644 King Charles left his headquarters at Oxford with 6,000 men, accompanied by 'two pieces of cannon and thirty coaches'. Travelling via Handborough, the King's army marched to Witney, where it was joined by other Royalist forces. The combined force then moved northwards via Woodstock to engage General Waller's Parliamentarian army at Cropredy on Saturday 29 June 1644.

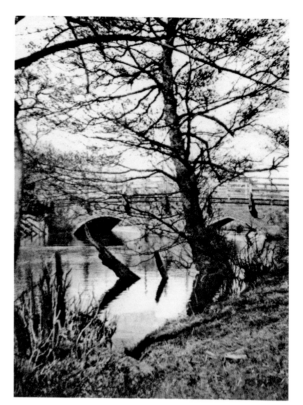

The battle centred around Cropredy Bridge (*above*). Two Parliamentary regiments had crossed from the west to the east bank of the Cherwell in order to engage the rear of the King's army, and for a time the Parliamentarians were successful. However, the main body of the Royalist force then appeared on the scene, and Waller was forced back across the river. The King himself arrived 'about five of the clock, and drew us off the top of a hill', recalled the diarist Richard Symonds, a member of the King's army. It was at first thought that Waller had been killed 'but it proved a lye'.

As afternoon turned to evening, the rival forces were still in the field; the Royalists were on the east bank of the river with their headquarters at Williamscott, while the Parliamentarians occupied the high ground around Hanwell and Bourton. This situation continued throughout the following Sunday, but as evening approached the King received news that Parliamentary reinforcements were approaching, and on Monday 1 July the Royalists withdrew. The unfortunate General Waller, who had lost his artillery and seen many of his men run away, made no attempt to pursue the enemy – although at the end of the battle his own forces still held the disputed bridge. Part of Cropredy village can be seen below.

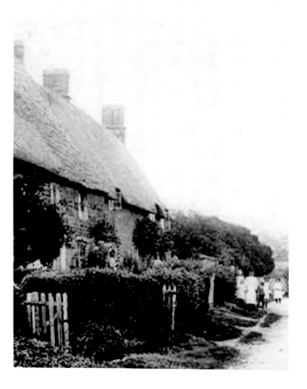

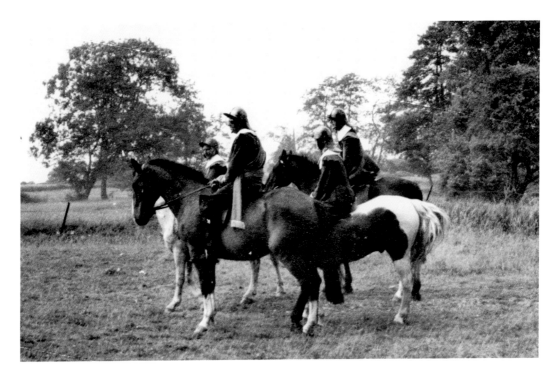

Cropredy: The Battle of Cropredy Bridge

The lack of commitment that had been displayed by General Waller's soldiers at Cropredy was only too obvious to Oliver Cromwell, who described the Parliamentary soldiers as 'decayed serving-men, and tapsters and such kind of fellows'. He argued that Parliament required 'men of a spirit' who knew what they were fighting for – the result being the creation of 'The New Model Army', which was formed in January 1645 and won the war in 1646. The pictures depict Civil War enthusiasts at Cropredy in 1970.

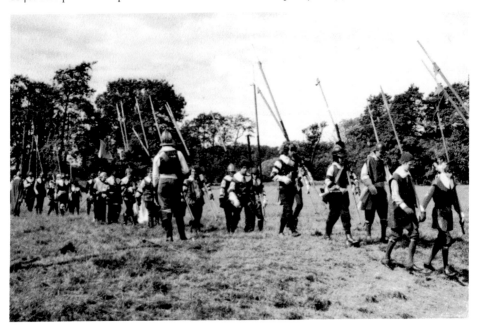

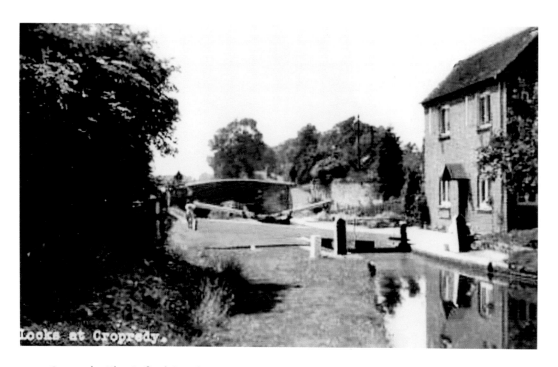

Looks at Cropredy.

Cropredy: The Oxford Canal

The Oxford Canal, which skirts the eastern side of Cropredy, was incorporated by Act of Parliament in 1769, and opened between Hawkesbury Junction and Banbury around 1778. The engineers were James Brindley (1716–72) and Samuel Simcock. The canal was extended southwards to Oxford in 1789–90 and, although rapidly eclipsed by the railway, the waterway continued to carry commercial traffic until the 1950s. The view above shows the locks near Cropredy, while the colour photograph below was taken about 2 miles to the south.

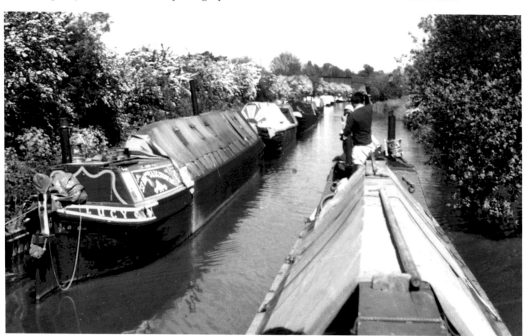

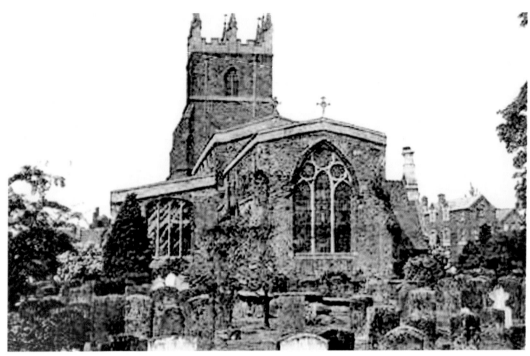

Deddington: The Church of St Peter and St Paul

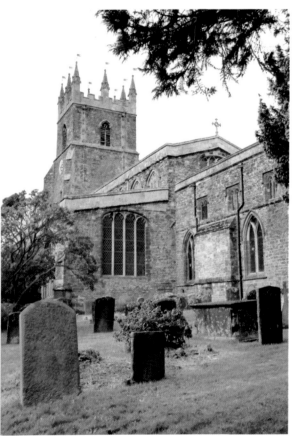

The Domesday Book reveals that in 1086 Oxfordshire was one of the most prosperous counties in England, and 'Dadintone', a manor of 36 hides belonging to Odo, Bishop of Bayeaux, was one of the largest settlements in the area, with a population of around 500. There was land for 30 ploughs and '140 acres of meadow and 30 acres of pasture woodland', together with '3 mills rendering 41 shillings and 100 eels'. A castle was constructed after the Norman Conquest, although only the earthworks now remain.

The parish church, dedicated to Saint Peter and St Paul, consists of a nave, aisles, chancel, two porches and a tower. The building was badly damaged when the tower and spire fell down in 1634, and although the tower was rebuilt in 1685, the spire was never replaced. The picture above probably dates from around 1920, while the colour view was taken in 2012.

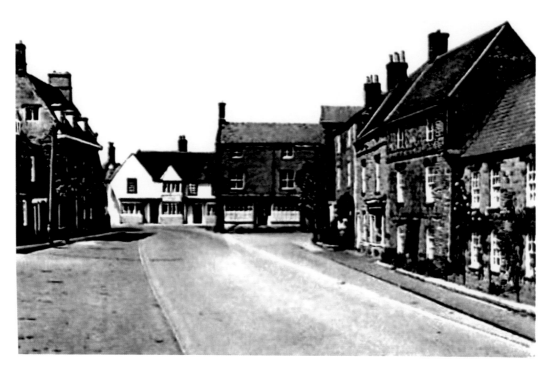

Deddington: The Market Place, Looking North

The picture above shows the north end of the Market Place around 1912, while the colour view was taken a century later. The tall house, with the prominent cornice that can be seen to the left in both pictures, is of seventeenth-century origin, and is known as Corner House. The white, gabled building at the north end of the square is the King's Arms, which may be even earlier. In 1852 the proprietor of this old coaching inn was Edward Hatton.

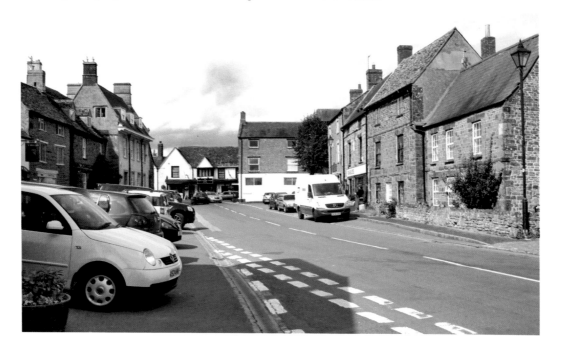

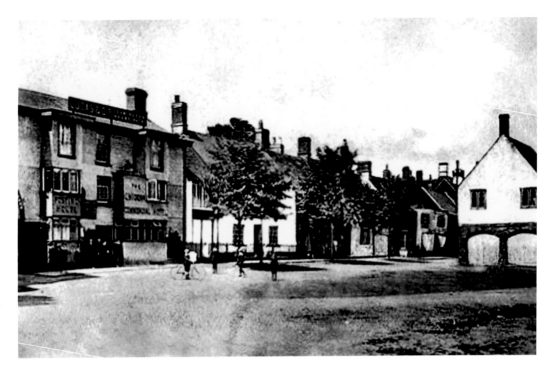

Deddington: The Market Place and The Unicorn Inn

An old postcard showing the west side of the Market Place, probably around 1910; the building on the extreme left with the bay windows is The Unicorn Inn. The modest town hall, in the centre of the Market Place, was erected around 1806 to replace an earlier building. The ground-floor arches were, at one time, blocked up, although they have now been opened out. The colour photograph, taken in 2012, reveals that very little has changed in this part of the town.

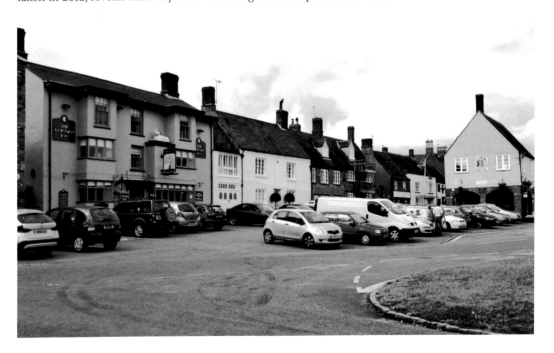

Deddington: High Street and New Street

New Street, now part of the A4260, was probably laid out during the Middle Ages in an attempt to expand the town and, in the fullness of time, it became Deddington's main thoroughfare, the northern end being renamed 'High Street'. The view above is looking southwards along the High Street towards Oxford around 1912, while the recent colour view was taken from the same vantage point a century later. The three-storey house on the right-hand side is recognisable in both photographs.

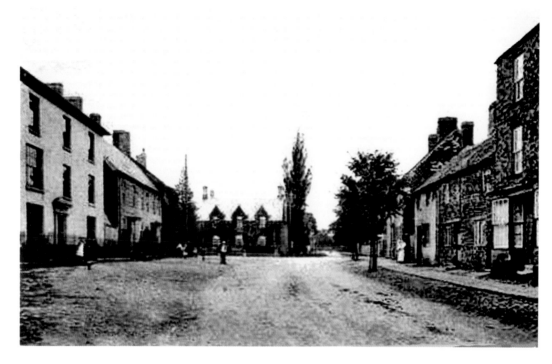

Deddington: High Street, Looking North

The picture above shows the north end of the High Street around 1912, while the colour photograph was taken in 2012. The three-storey house that can be seen on the left in the old photograph has lost its rendering, but otherwise little has changed. The traffic lights visible on the extreme right of the recent picture mark a busy road junction named Horsefair, which gives access to the Market Place. Hempton Road, to the left, leads to the outlying hamlet of Hempton.

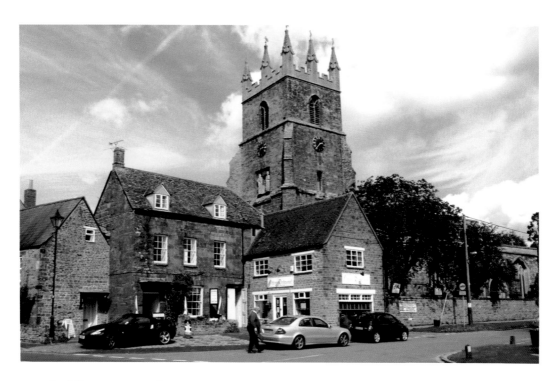

Deddington: General Scenes

Two additional views of Deddington. The view above provides a detailed glimpse of buildings on the east side of Market Place, with the reconstructed tower of the parish church rising impressively in the background. The lower view shows an alleyway known as 'The Tchure', which forms a pedestrian link between High Street and Market Place – 'tewry' being an Oxfordshire dialect word for a yard or alleyway. Both views show the distinctive brown ironstone of the Banbury area.

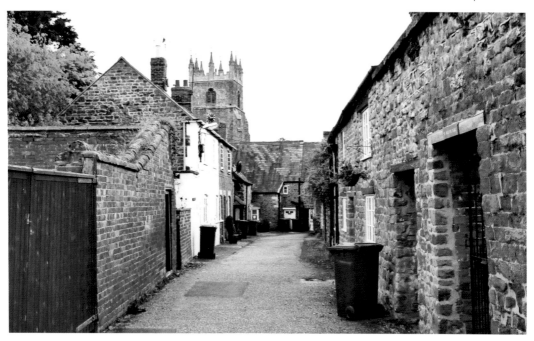

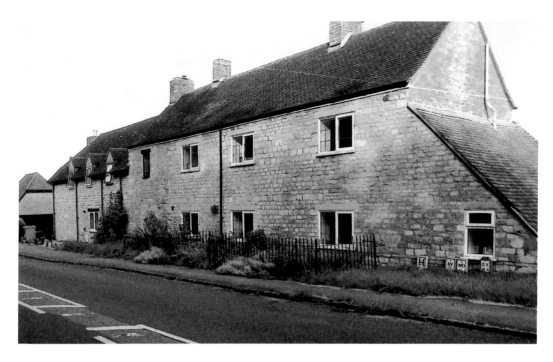

Finstock: The Waterloo Arms

These pleasant but undistinguished Cotswold stone cottages beside the busy B4022 Witney Road at Finstock were once a local alehouse known as The Waterloo Arms. One of the former landlords was also the village blacksmith. Finstock is an attractive, Cotswold-style village on the south side of the Evenlode Valley (the neighbouring settlements of Ramsden and Charlbury are included in *The West Oxfordshire Cotswolds*).

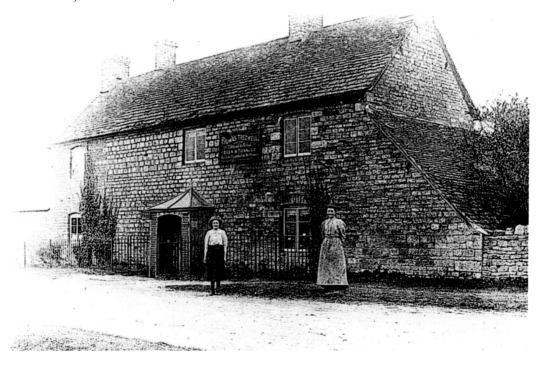

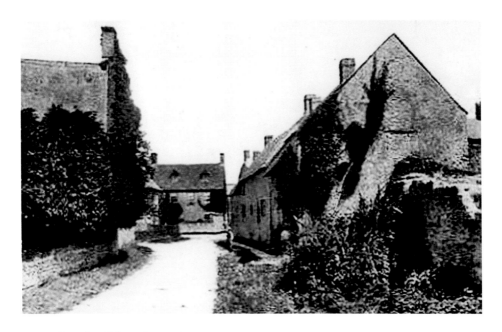

Fritwell: Old Buildings in Raghouse Lane

Fritwell is an extensive village, situated about 8 miles south-east of Banbury. The sepia postcard shows old houses in the quaintly named Raghouse Lane. The building visible in the distance is the Rose & Crown, a traditional village pub; in 1852 the landlord was a man called Tebby, who is described in *Gardner's Oxford Directory* as a 'victualler'. The photograph below shows the same scene in 2012; the cottages look well cared-for, but the pub has recently been closed.

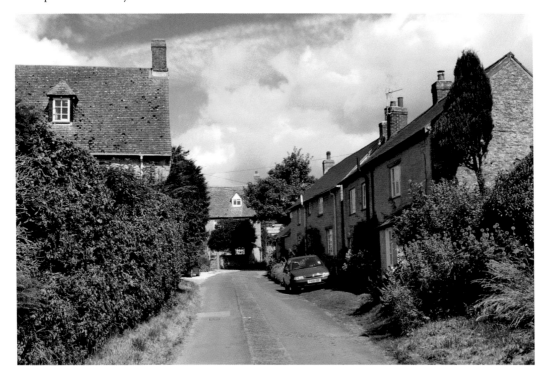

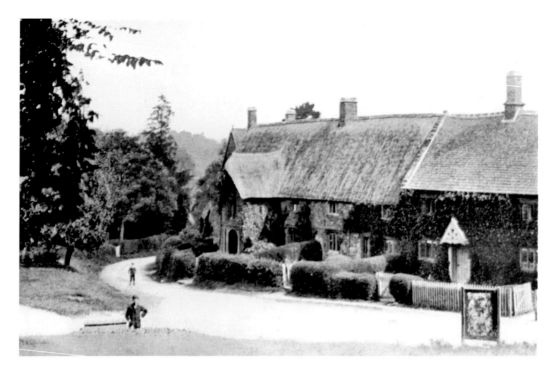

Great Tew: A Landscaped Village

Great Tew is a classic 'chocolate-box' village, which owes much to the work of the Scottish writer and landscape gardener John Claudius Loudon (1783–1843). Loudon, who managed the estate between 1809 and 1811, implemented a comprehensive improvement scheme, as a result of which the village acquired a park-like appearance. The picture above shows Old Road around 1930, while the photograph below, from November 2012, looks eastwards along 'The Lane' towards Old Road.

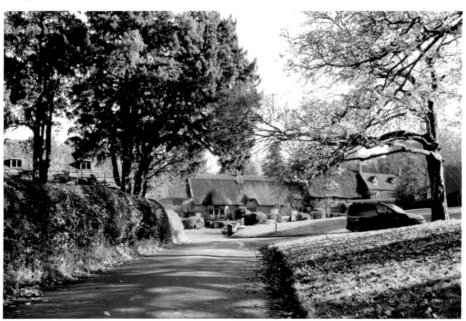

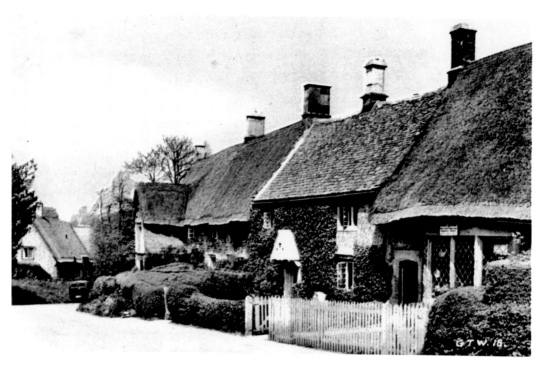

Great Tew: Cottages in Old Road

Two detailed views showing cottages at the north end of Old Road, the upper view being a commercial postcard, thought to be from around 1930, while the lower photograph was taken in November 2012. The thatched building on the left is known as Porch House, and it forms part of a row of predominantly seventeenth-century buildings that face the green and are effectively the centre of the village. The rustic porches were probably added by Loudon.

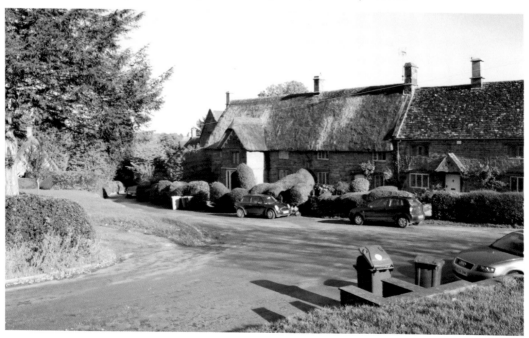

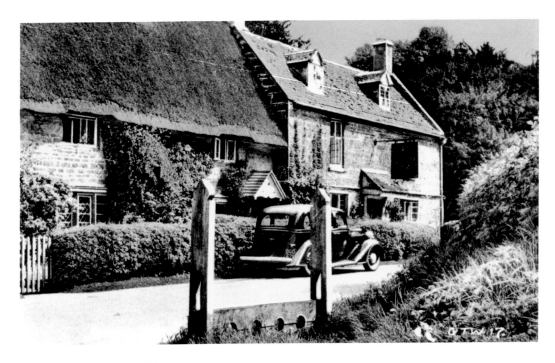

Great Tew: The Falkland Arms

The Falkland Arms, in the same row of cottages as Porch House, commemorates the Falkland family, who had owned the estate during the seventeenth century. Lucius Cary, the second Viscount Falkland (1609/10–43), and perhaps the most famous member of his family, made Great Tew the centre of a small circle of radical intellectuals, most of whom became Royalists during the Civil War. The picture above is from a commercial postcard, and the colour photograph below was taken in 2012.

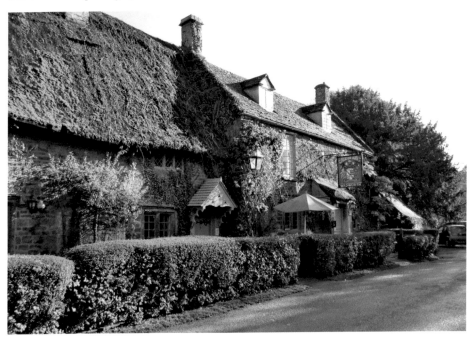

Great Tew

(*Above*) A further view showing old cottages in Old Road, looking southwards, probably around 1930. By the early 1970s the village had become extremely dilapidated, and there were fears that some of the cottages would be demolished, but through the efforts of Major Eustace Robb (1899–1985), an Army officer and pioneer television producer who acquired the estate in 1962, the derelict properties were gradually restored. (*Below*) A recent photograph, looking northwards along Old Road towards the centre of the village.

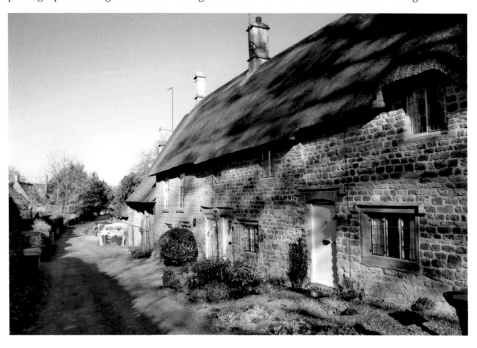

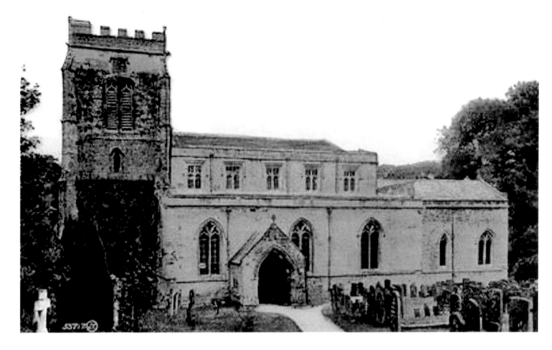

Great Tew: St Michael's Church

(*Above*) The parish church, from an Edwardian postcard. St Michael's church, originally Norman, was rebuilt in the thirteenth and fourteenth centuries. It incorporates a nave, aisles, chancel and a west tower. The nave has a raised clerestory in the Perpendicular style. Lucius Carey, who was killed in a suicidal charge at the first Battle of Newbury in 1643, is buried in the churchyard, although no memorial was provided until 1885. (*Below*) The church on a sunny winter's day in November 2012.

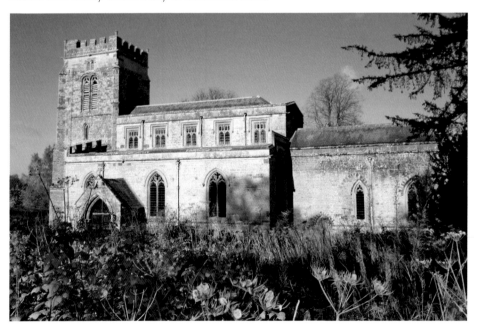

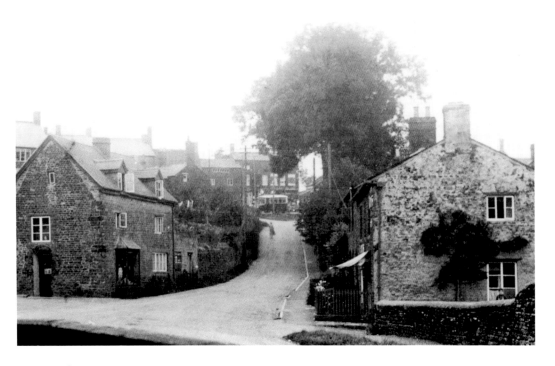

Hook Norton

Hook Norton was supposed to have been the scene of a massacre of the Danes during the Viking Wars. Later, in more peaceful times, the village was rebuilt in the rust-brown Marlstone of the Oxfordshire ironstone district. Perhaps surprisingly, Hook Norton was once an industrial centre, with many ironstone workings in the immediate vicinity, and a now famous brewery, which was founded in 1849. The picture above is looking up towards the centre of the village around 1930, while the colour photograph shows Bell Hill in 2012.

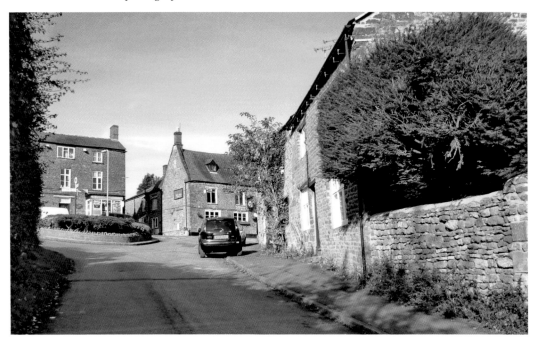

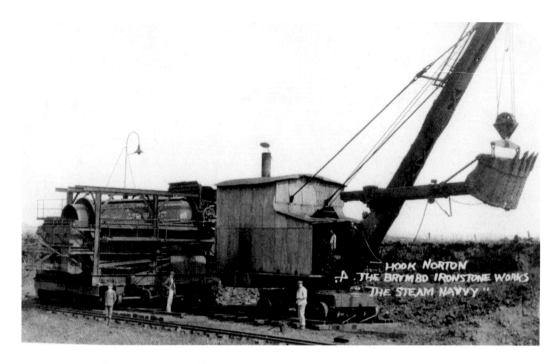

Hook Norton: The Ironstone Workings

The view above shows a Ruston 20-ton steam navvy at work in the Brymbo Steel Company's extensive ironstone workings at Hook Norton; the machine behind the navvy was a rotary screen. Ironstone extraction in the area around Hook Norton ceased in the mid-1950s and the Brymbo quarry closed in June 1946. Thereafter, Hook Norton reverted to a condition of rural tranquillity, as exemplified by the lower picture, which shows some old ironstone cottages in the very centre of the village.

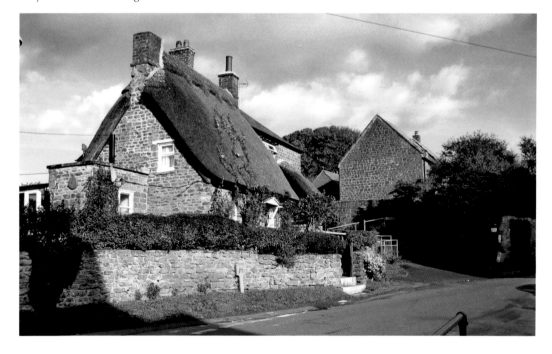

Hook Norton

Hook Norton consists of a veritable maze of narrow streets. The main street, known as High Street (*above*), merges into Netting Street at one end and Chapel Street at the other. At its eastern end, Chapel Street joins the aptly named East End, which continues eastwards as Station Road. (*Below*) A tranquil corner of the village, probably photographed around 1912.

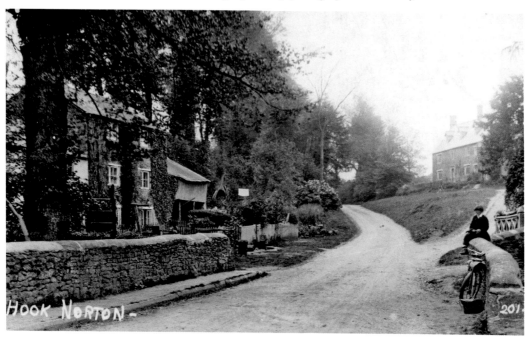

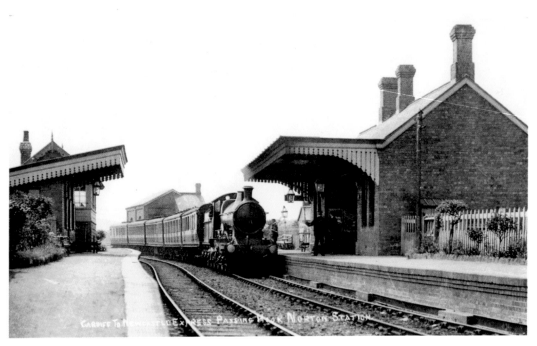

Hook Norton: The Station and Viaducts

The eastern section of the Banbury & Cheltenham Direct Railway was opened between Chipping Norton and Kings Sutton in 1887, its primary aim being the transport of local ironstone. Hook Norton station (*above*) was equipped with a crossing loop and platforms for up and down traffic. The goods yard, with two sidings, was situated to the west of the platforms on the up side, while further sidings were available for ironstone traffic on the down side of the line.

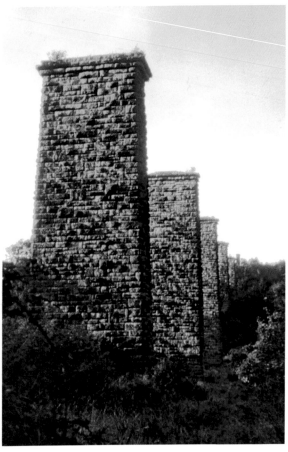

As eastbound trains approached Hook Norton, they passed over two closely spaced viaducts. Hook Norton No. 2 Viaduct had eight lattice girder spans, the horizontal girders being supported on seven gently tapering stone columns, while the neighbouring No. 1 Viaduct was slightly shorter, with five spans. The railway through Hook Norton was closed to passengers in 1951 and to freight traffic in 1958, but the viaduct piers remain as monuments to the industrial age.

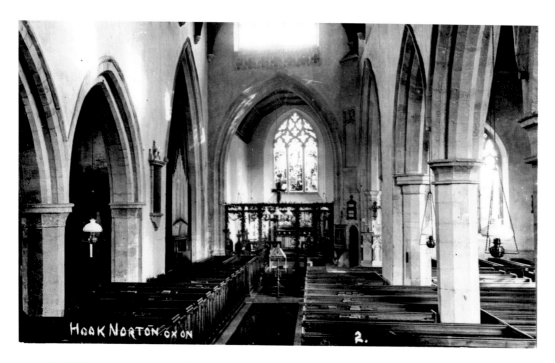

Hook Norton: St Peter's Church

The church of St Peter, which occupies a prominent position near the centre of the village, has a Norman chancel, although the decorated east window was added during the fourteenth century. The nave is quite spacious and its most interesting feature is a Norman font with carvings of Adam and Eve. Adam is grasping what appear to be gardening tools, while Eve is holding an apple; another carving represents Sagittarius with his bow and arrow.

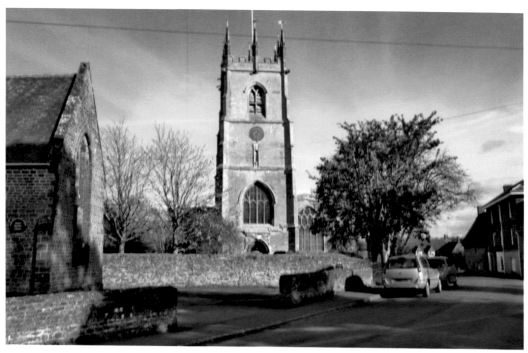

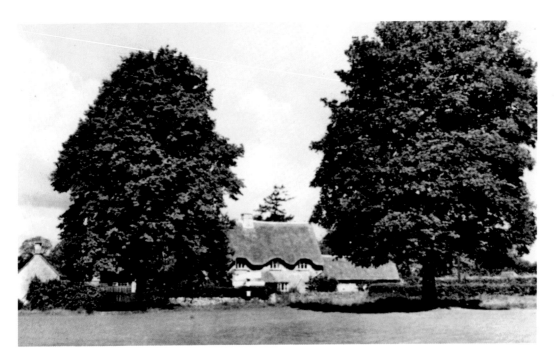

Kingham: Cottages on the Green

Kingham, a very pleasant village in the Evenlode Valley, chiefly consists of one long main street, a large village green and a heavily restored fifteenth-century parish church. The limestone cottages are of typical Cotswold appearance, although many of them have thatched roofs instead of the limestone slates seen further to the south and west. The pictures show a thatched cottage on the green with upswept eyebrow dormers. The picture above dates from around 1955, while the colour photograph was taken in 2012.

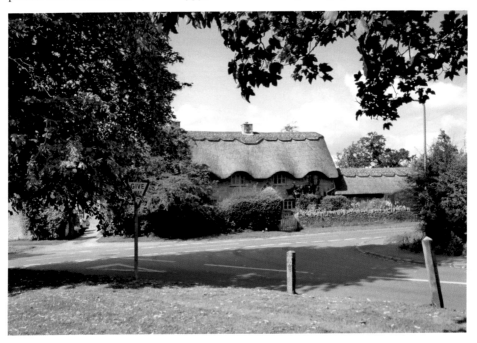

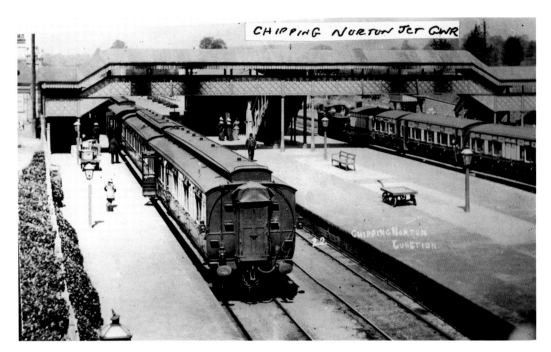

CHIPPING NORTON JCT GWR

CHIPPINGNORTON
JUNCTION.

Kingham: The Railway Station

Although Kingham is merely a rural village, it was formerly the site of a large railway station, which had first been opened in 1855 in connection with the Chipping Norton branch. Six years later, the opening of the Bourton-on-the-Water Railway led to a further increase in facilities, while in the 1880s the station – originally known as Chipping Norton Junction – was completely rebuilt as a four-platform interchange point between the Oxford to Worcester and Banbury to Cheltenham lines.

Kingham station has remained in operation, but the extensive yellow-brick buildings provided as part of the 1880s rebuilding scheme have now been replaced by a much smaller station building, and the connecting lines to Chipping Norton, Banbury, Bourton-on-the-Water and Cheltenham have been closed. The picture above shows the station in its Edwardian heyday, while the colour photograph shows the two remaining platforms; both views are looking north towards Worcester.

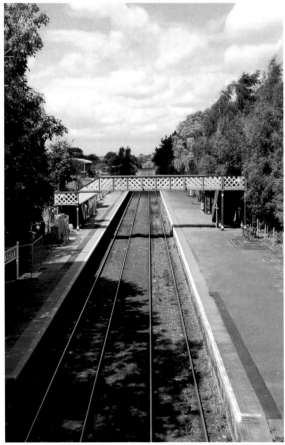

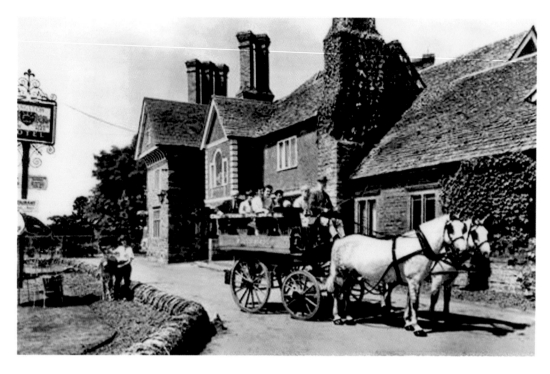

Kingham: The Langston Arms Hotel

Conveniently situated next to the railway station, and connected to it by a lattice girder footbridge, the Langston Arms was a large hotel that was built in the 1870s at the expense of the 3rd Earl of Ducie. A cattle market was established to the east of the hotel, which also became a regular meeting place for the Heythrop Hunt – a horse-dock being provided by the GWR alongside the main line. The hotel, pictured below, is now a nursing home.

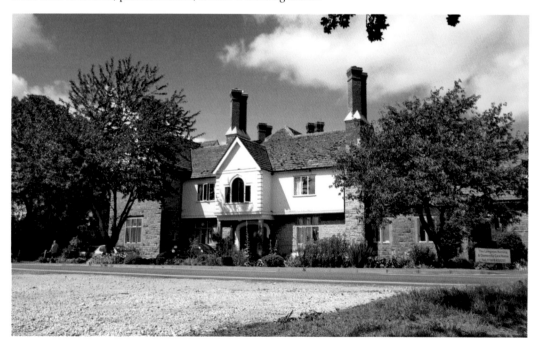

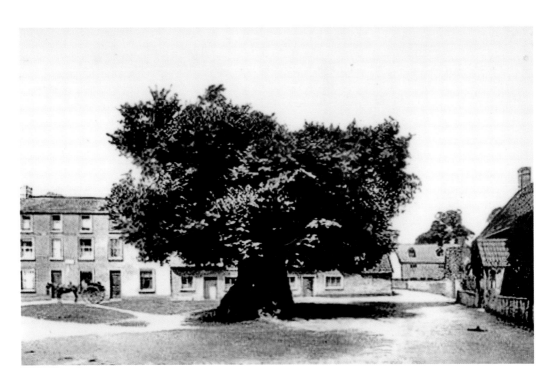

Kirtlington

Kirtlington, a small village about a mile to the east of the River Cherwell, boasts two attractive greens. The 'hollow tree' at South Green, depicted in the above postcard view from around 1912, has long since disappeared, although the houses and cottages have survived more or less unchanged, as shown in the colour photograph. Kirtlington Park, to the north-east of the village, was the home of Sir George Dashwood, who lost three sons during the First World War.

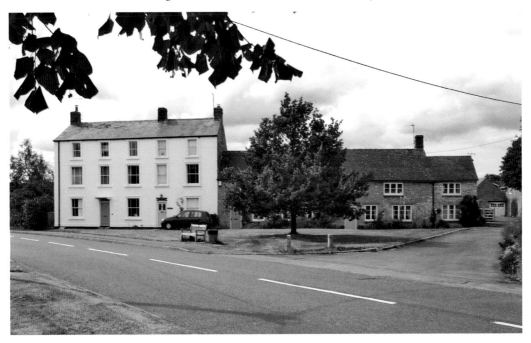

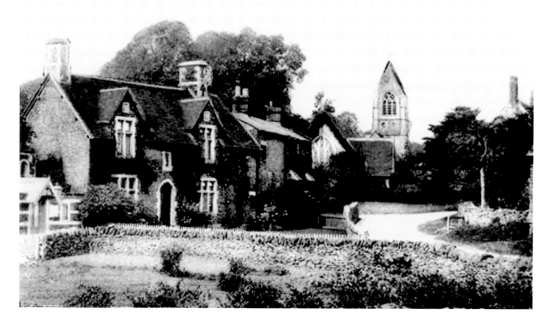

Little Tew: the Church of St John the Evangelist

Situated about three quarters of a mile to the west of Great Tew, Little Tew was originally a hamlet, but it acquired its own church during the Victorian period. The church of St John the Evangelist was consecrated in 1853; the architect was George Street. The 'saddleback' tower that can be seen in both photographs was designed by C. Buckeridge and added in 1869. The Edwardian postcard above is looking north along Enstone Road, while the colour photograph was taken in 2012.

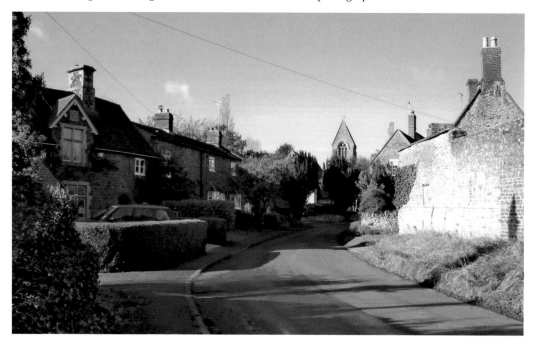

Lower Heyford: Station Road Looking East

There are two Heyfords, Lower Heyford being in the Cherwell Valley, while neighbouring Upper Heyford is sited on higher land about a mile to the north. In 1918, Upper Heyford became the site of a large military aerodrome, which became the home of No. 16 Operational Training Unit during the Second World War. However, Lower Heyford remained a tranquil village, as exemplified by these two views of Station Road, the sepia postcard view dating from around 1930, whereas the colour photograph was taken in 2012.

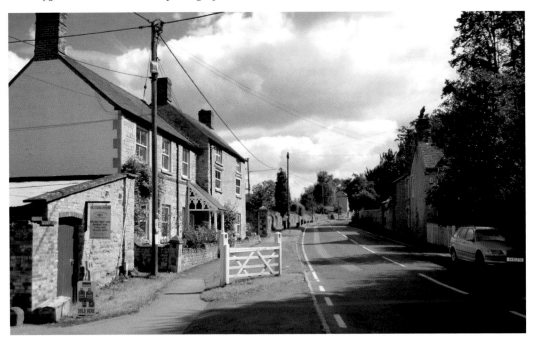

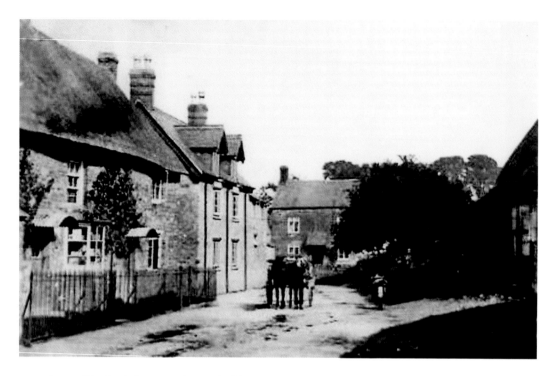

Lower Heyford: Cottages in Freehold Street

Heyford was once a busy village which, according to *Gardner's Directory*, 'commanded an extensive trade' owing to its proximity to the Oxford Canal and the recently opened Oxford to Banbury railway line. However, by the end of the Victorian period it had become a quiet, rural backwater, as shown in these two views of Cotswold-style buildings in Freehold Street. The postcard above dates from around 1920, while the colour photograph was taken roughly eighty years later, in August 2012.

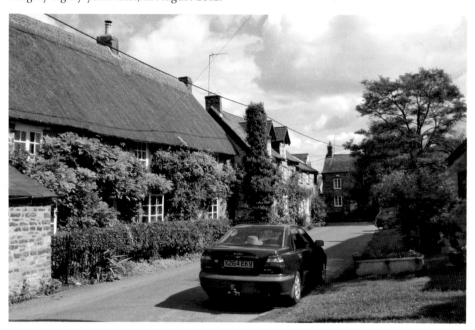

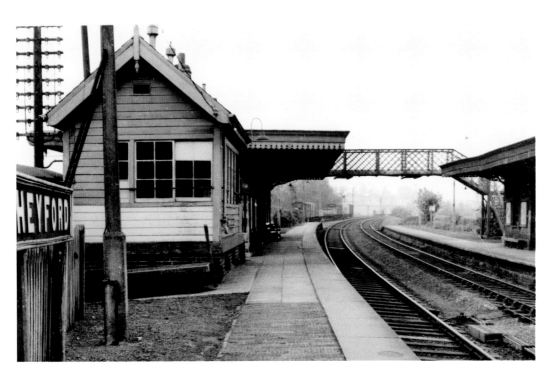

Lower Heyford: The Railway Station

Heyford station was opened on 2 September 1850 as an intermediate stopping place on the Oxford to Rugby line, and it was equipped with Brunel-designed station buildings. These contrasting views show the down platform in the 1960s and in 2012. The station buildings have been replaced by waiting shelters and the signal box has been demolished, although the footbridge has been renewed. The Oxford Canal is situated immediately to the east of the station.

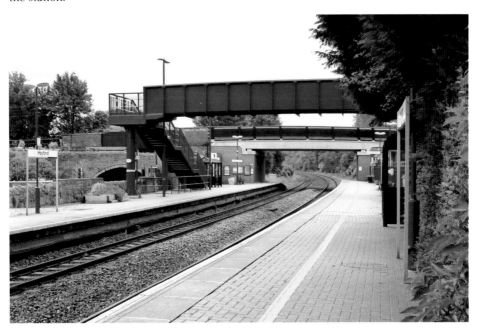

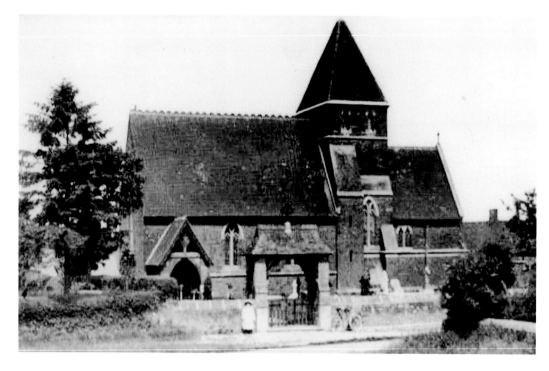

Milton: St Mary's Church

Confusingly, there are four Miltons in Oxfordshire, including a small hamlet in the parish of Adderbury, which acquired its own church in 1856. Designed by the architect William Butterfield (1814–1900), this substantial Victorian structure incorporates a nave and chancel, together with a small porch and a central tower. The tower has huge buttresses and a pyramidal roof – the overall appearance being, in many ways, reminiscent of the fortified churches found in the Aisne district of north-eastern France.

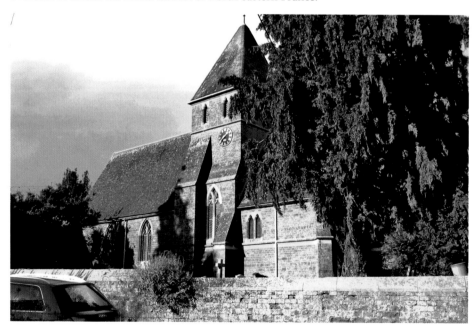

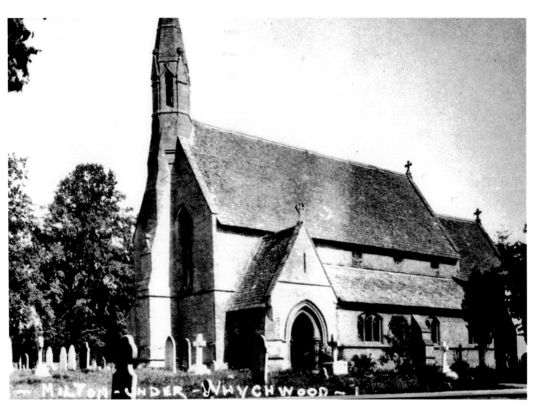

Milton-under-Wychwood: The Church of St Simon and St Jude
Situated immediately to the west of Shipton-under-Wychwood, Milton-under-Wychwood was, in 1841, a township in the parish of Shipton-under-Wychwood with a population of 660. The church, comprising a nave, aisles, chancel and porch, was designed by George Emund Street and consecrated on 28 October 1854. The necessary funding was provided through the munificence of James Langston MP, the Revd Anthony Huxtable, and his wife, Mrs Huxtable. The west wall is unusual – a massive central buttress combined with a 'pepper pot' bell turret.

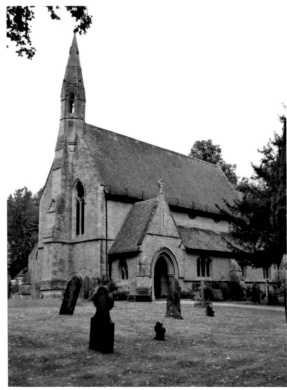

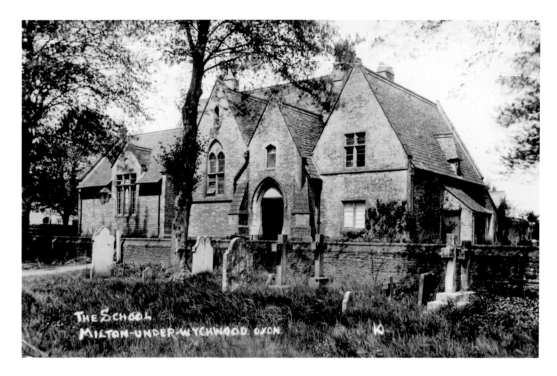

THE SCHOOL
MILTON-UNDER-WYCHWOOD. OXON.

Milton-under-Wychwood: The Old School

Milton's former national school, now a private house, was built around 1854 as an Anglican school for forty to fifty pupils. The architect was again G. E. Street. Like many Church of England schools, it was built in the Gothic style, and sited near the parish church, so that the vicar could exercise a degree of control over the syllabus and keep a wary eye on the day-to-day conduct of the school. The postcard above was sent in 1913, while the photograph below is from 2012.

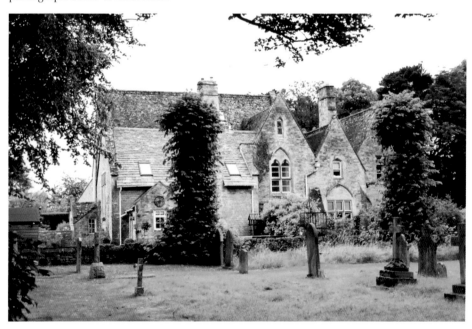

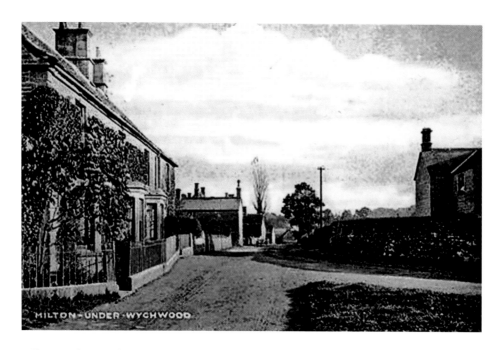

Milton-under-Wychwood: Houses in Shipton Road

The old postcard above, dating from around 1912, shows the junction of Green Lane and Shipton Road, with a row of substantially built Cotswold stone houses occupying a prominent position to the left. The lower photograph reveals that these houses have survived more or less unaltered, but changes have taken place in relation to the road network. Shipton Road, which diverges to the right, is now regarded as the 'main road', while Green Lane is merely a cul-de-sac.

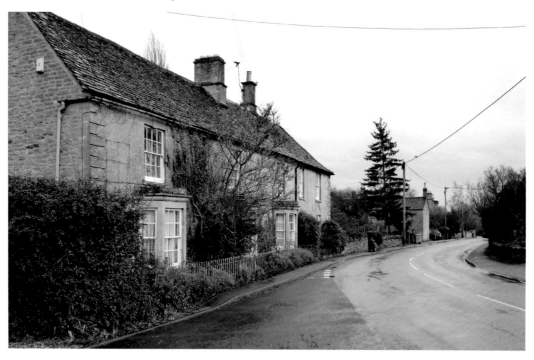

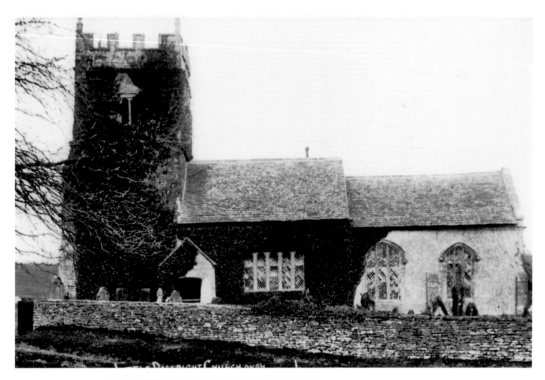

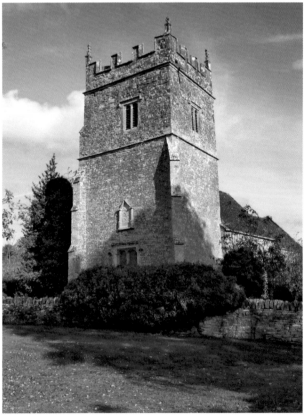

Rollright: The Church of St Philip

There are two Rollrights: Great Rollright, the largest of the two settlements, is around 3 miles to the north of Chipping Norton, while nearby Little Rollright is a tiny village in a remote setting. The latter consists of little more than St Philip's church, pictured, a manor house and the manor farm.

St Philip's church incorporates a nave, chancel and a west tower – the latter bearing an inscription proclaiming that it was built (or perhaps rebuilt?) by William Blower in 1617. The church contains two monumental tombs with effigies, one of which is assumed to be William Blower, although they may both commemorate members of the Dixon family. The sepia view dates from around 1912, and the colour photograph was taken in October 2012.

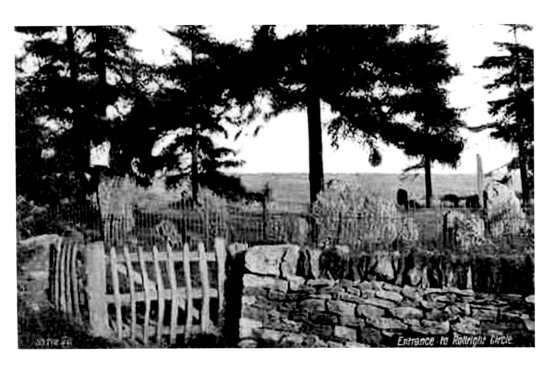

Entrance to Rollright Circle

Rollright: The Stone Circle

Situated on a hill above Great Rollright, near Chipping Norton, the Rollright Stones are as mysterious as the monuments at Stonehenge and Avebury. The stones consist of two circles, one about 100 feet in diameter, while the other encloses an area about 6 feet across; these are known as 'The King's Men' and 'The Whispering Knights' respectively. The old postcard view depicts the entrance to the circle, while the colour photograph shows the circle in 2012.

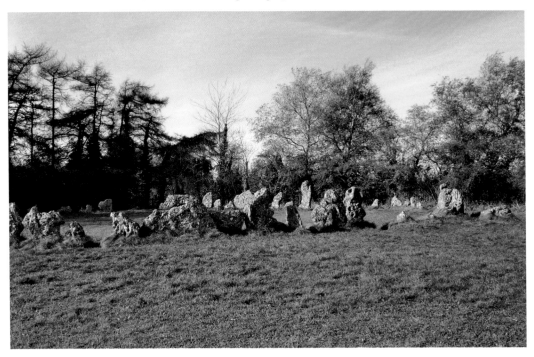

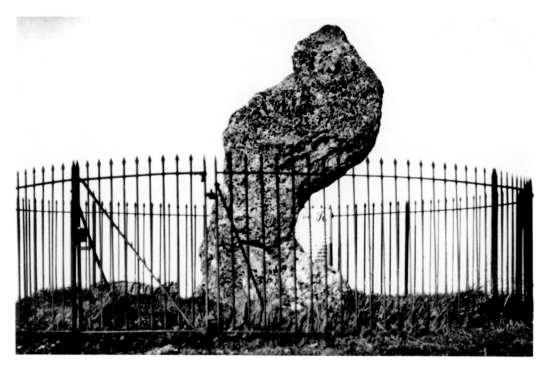

Rollright: The King Stone

Nearby, a gaunt monolith, standing about 8 feet high, is known as 'The King Stone'. The stones were said to have been the remains of a king and his army, who were turned to stone by a witch known as 'Old Mother Shipton', while the Whispering Knights were traitors who plotted against the unfortunate king! Many of these fanciful old legends were collected for posterity by the archaeologist Sir Arthur Evans, who published them in *Folklore* (1895). The strange-looking object in the right distance is a dead tree.

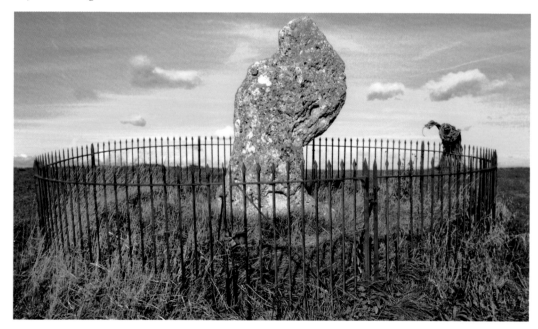

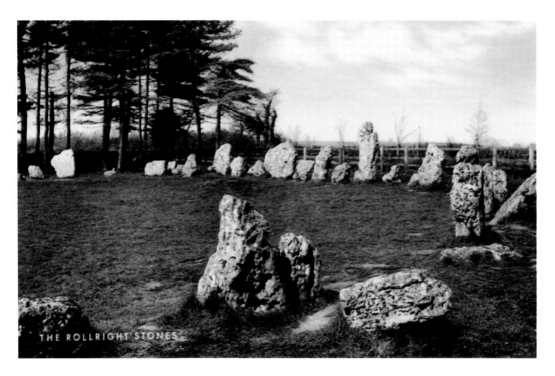

Rollright

Two further views of the Rollright Stones. The commercial postcard above possibly dates from around 1930, while the recent colour photograph was taken in November 2012. Notwithstanding the legends which surround the site, the stone circle is thought to date from the third century BC, while the Whispering Knights are the remnants of a burial mound – a dolmen with four uprights and a fallen capstone that would originally have been covered by an earth mound.

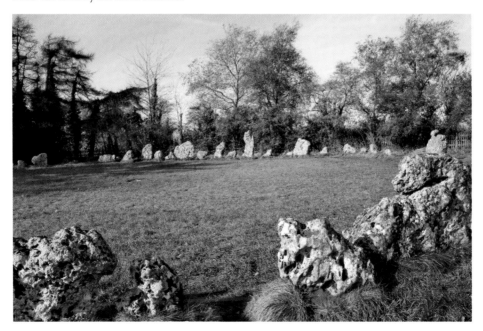

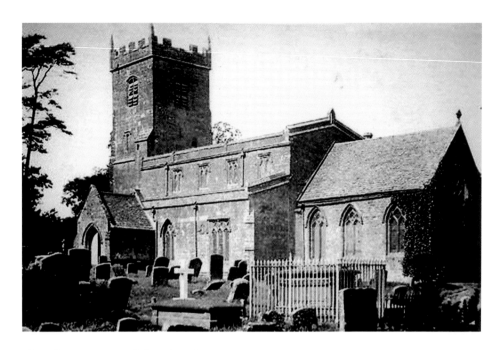

Shennington: Holy Trinity Church

Situated about 6 miles north-west of Banbury, the village of Shennington is situated on the west side of the Upper Sor Brook. Shennington is a typical ironstone village, clustered picturesquely around a village green. Holy Trinity church has a nave, aisles, chancel, porch and a west tower. The Norman chancel arch was moved to a new position in the north wall in 1879 as part of a restoration carried out by the Victorian architect John Loughborough Pearson (1817–97).

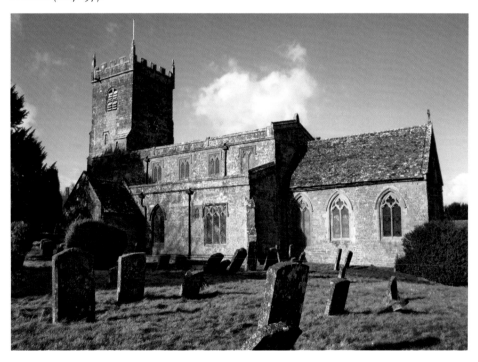

Shennington: The Village Green

(*Above*) A postcard view of the village green, probably dating from the 1930s. (*Below*) A recent photograph taken from a similar vantage point in January 2013. Holy Trinity church is now partially obscured by trees, which have proliferated in the intervening years.

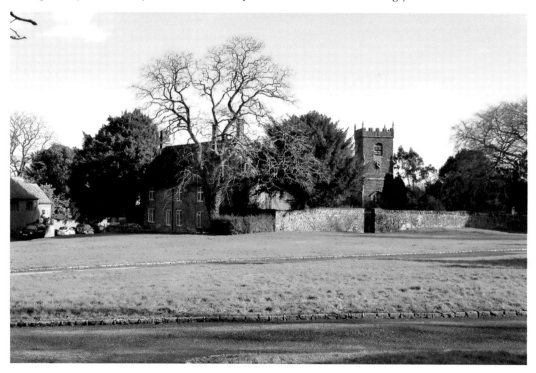

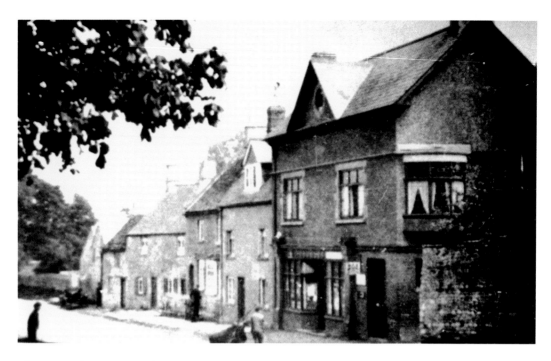

Shipton-under-Wychwood: Church Street

As its name implies, Shipton-under-Wychwood, a large village in the Evenlode Valley, was formerly associated with the Royal Forest of Wychwood and, in spite of deforestation in 1852, there is still much woodland in the parish. The picture above, dating from around 1930, shows a row of houses in Church Street on the south side of the green; the large building on the right is the post office. The colour view shows the same buildings in August 2012.

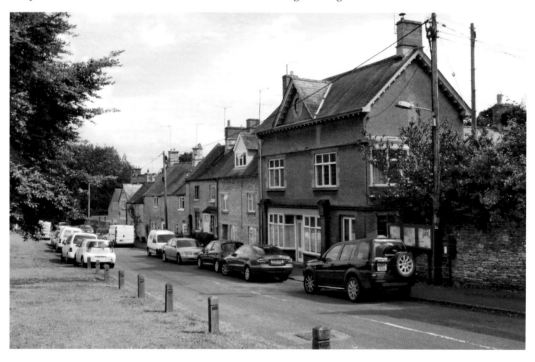

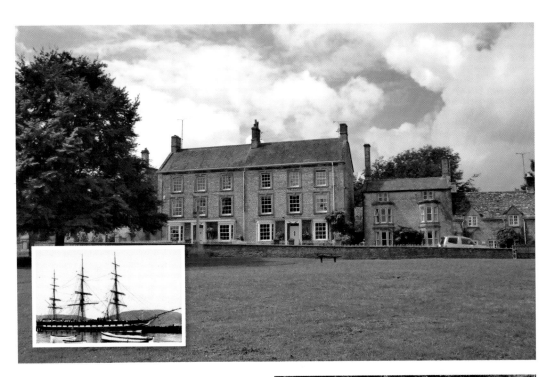

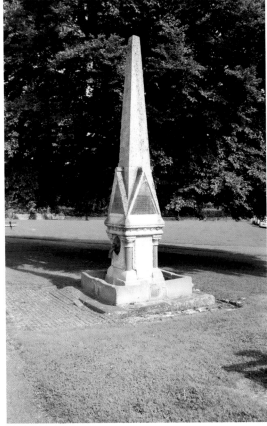

Shipton-under-Wychwood: The Cospatrick Memorial and the Village Green

The picture above shows the village green, which has two memorials, one of these being the war memorial, while the other (*right*) commemorates a Victorian shipwreck. In September 1874, a party of seventeen emigrants from Shipton-under-Wychwood sailed for New Zealand aboard the *Cospatrick*, a three-masted sailing vessel. Fire broke out on the night of 17 November when the vessel was 700 miles from the Cape of Good Hope and, despite frantic efforts to save the ship, she was soon engulfed in flames. The crew managed to launch two boats, each carrying thirty survivors, although neither of the boats had any food or water. One of the boats foundered, but the remaining one was picked up by the *Sceptre* ten days later – by which time it contained just three living men, who had subsisted by eating the bodies of their dead companions. In all, 470 people perished in the disaster. The inset shows a 'Blackwall Frigate', used on the New Zealand run. The ill-fated *Cospatrick* was of very similar appearance.

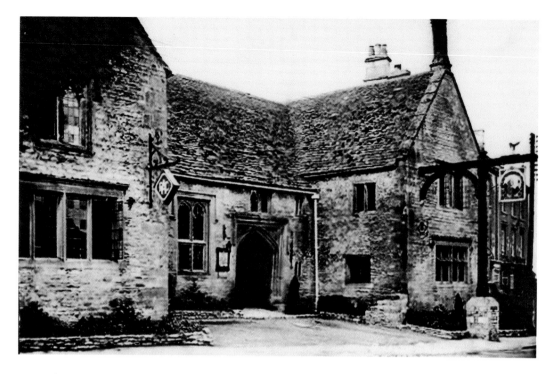

Shipton-under-Wychwood: The Crown

The fifteenth-century Shaven Crown, which is said to have been a guesthouse associated with nearby Bruern Abbey, is clearly one of the oldest buildings in Shipton. It is a typical medieval structure, with a central hall flanked by two transverse cross wings; the hall portion retains its medieval double collar beam roof. The picture above shows this historic hostelry during the interwar years, probably around 1935, while the lower photograph was taken in October 2012.

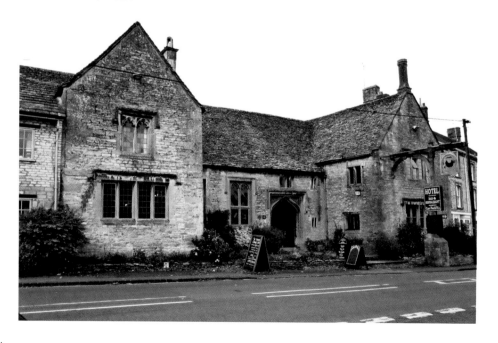

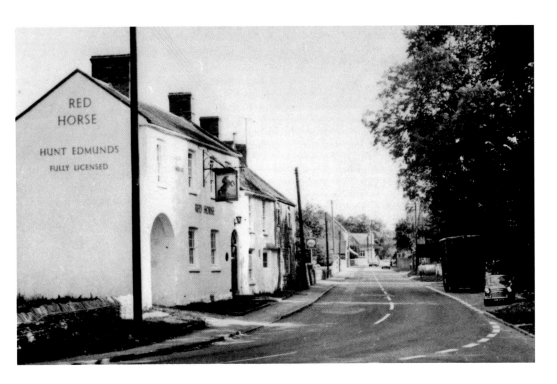

Shipton-under-Wychwood: The Red Horse

Gardner's Directory of Oxfordshire suggests that, in 1852, Shipton had just two pubs, one of these being the historic Crown, while the other was the Red Horse, shown above around 1960 and below in 2012. The oldest part of the building, which features a stone-slated roof and a projecting bay window, can be seen to the right. It was probably built around 1700, whereas the taller left-hand portion is clearly a nineteenth-century addition. This historic pub was closed at the time of writing.

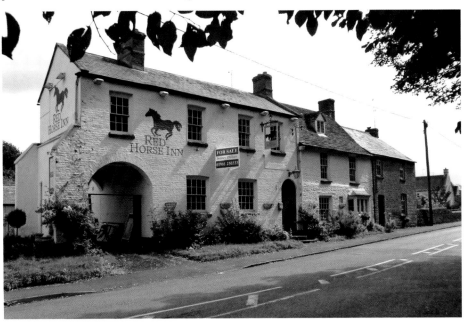

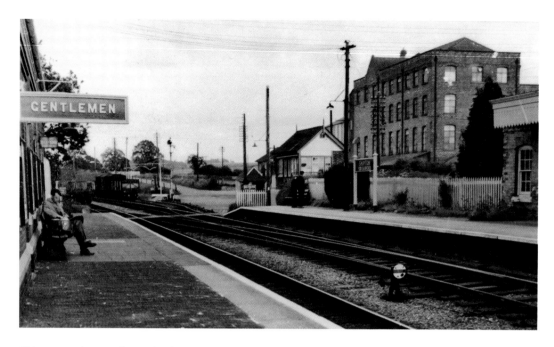

Shipton-under-Wychwood: The Railway Station

Shipton station was opened by the Oxford, Worcester & Wolverhampton Railway on 4 June 1853. The original wooden station buildings were replaced in the late Victorian period, when the GWR constructed a new, brick-built station in its standard hipped-roof style, with tall chimneys and a projecting canopy. There was a fully equipped goods yard, while a private siding served the adjacent flour mill. Shipton remains in operation as a passenger-only stopping place, although its buildings have been demolished, as can be seen below.

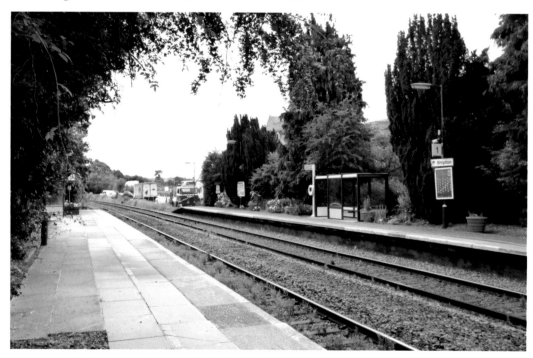

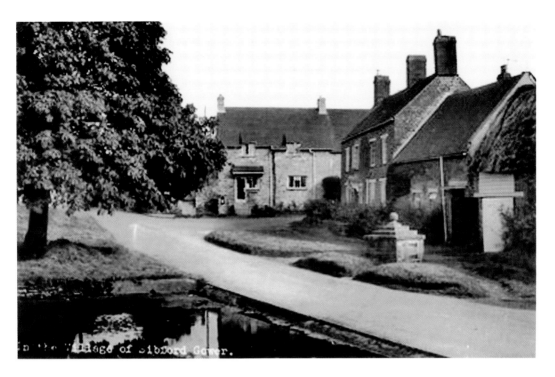

In the Village of Sibford Gower.

Sibford Gower: Main Street

Sibford Gower and the hamlet of Sibford Ferris are two closely-spaced settlements which face each other on either side of a narrow valley and form, in effect, one village. The sepia postcard shows thatched houses and cottages in Main Street, possibly around 1930, while the colour photograph was taken over eighty years later, in January 2013; the pond can be seen in both pictures.

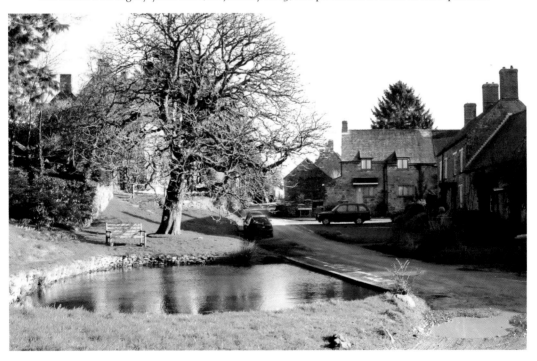

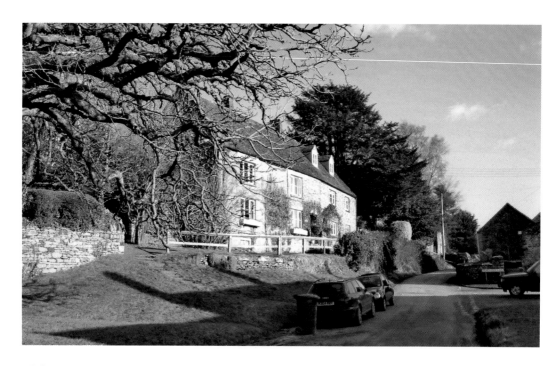

Sibford Gower: Old Houses in Main Street

These two views show different groups of houses in Main Street. The recent colour photograph is looking along Main Street from a position just eastwards of the village pond; and the sepia postcard shows a similar group of old stone houses in another part of the street. Main Street forms an end-on junction with Acre Ditch which, in turn, joins Hawk's Lane – thereby providing a road link between Sibford Gower and Sibford Ferris.

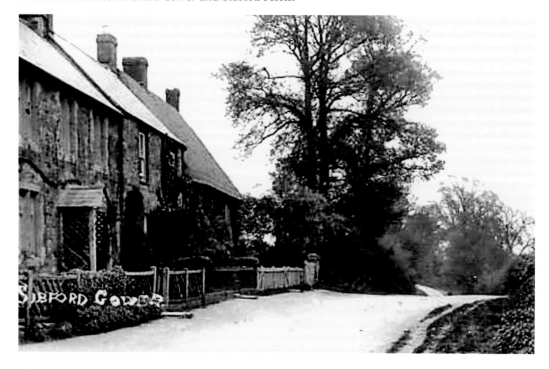

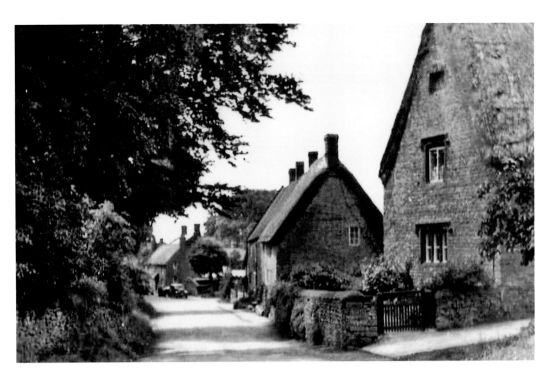

Sibford Ferris: Main Street

Perhaps confusingly, Sibford Ferris also has a Main Street. The postcard above is looking westwards along the street (*c.* 1930), and the colour photograph is looking eastwards in January 2012. The house with the tall gable that can be seen on the right in the sepia view is also visible in the recent photograph – it is at the rear of the red car, near the top of the hill.

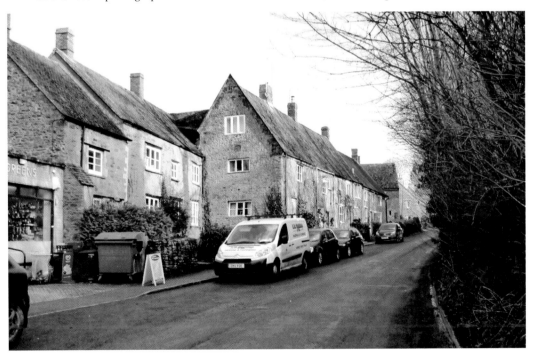

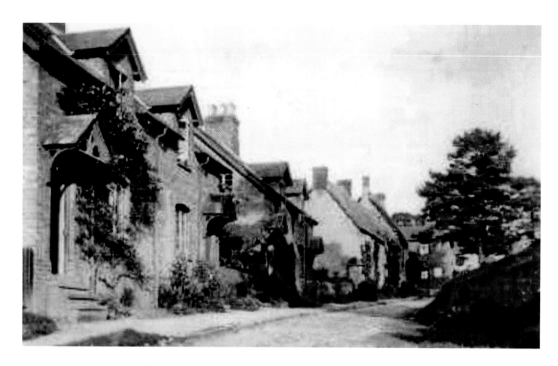

Somerton: Cottages in Church Street

Somerton, a village on the east side of the Cherwell, was once the home of the Fermors, a prominent local family, but their Tudor mansion was dismantled in the eighteenth century and only fragments now remain. The sepia postcard view depicts Victorian red-brick cottages in Church Street, probably around 1930, while the colour photograph shows the same houses in 2012; the churchyard is on the right in both photographs.

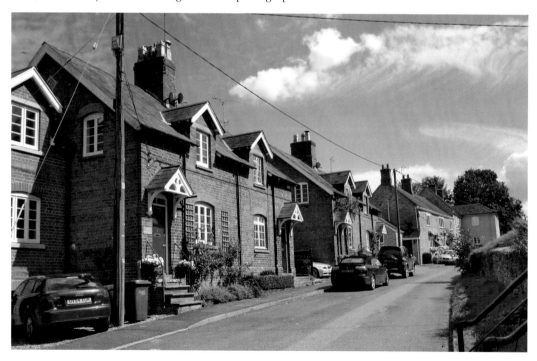

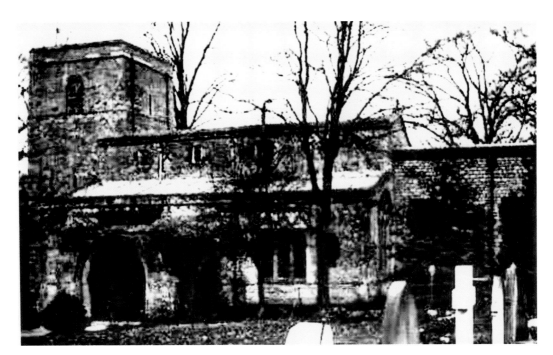

Souldern: St Mary's Church, William Wordsworth and the Reverend Robert Jones

The small church, dedicated to St Mary, which was restored in 1906, consists of a nave, south aisle, chancel, porch and west tower. Souldern has associations with the poet William Wordsworth, who visited the village in 1820 and immortalised the village in his sonnet 'Ode on an Oxfordshire Parsonage'.

Wordsworth was a close friend of the Revd Robert Jones (*c.* 1771–1835), who had accompanied him on a 3,000-mile walking tour through Europe in 1792. Unfortunately, the Revd Jones seems to have neglected his duties at Souldern, leaving much of the work to his curate Sir William Clerke. Although Jones was Rector from 1787 until his death in 1835, he spent around half of his tenure at home in his native Wales. The old parsonage house was demolished in the nineteenth century, but the church looks much as it did at the time of William Wordsworth's visit.

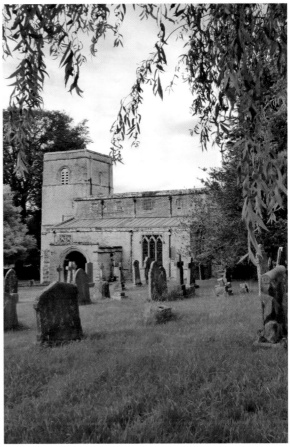

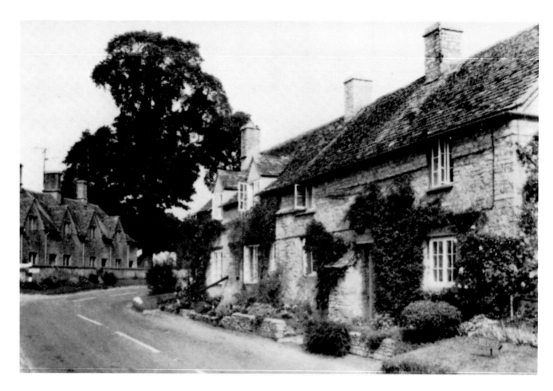

Spelsbury

Spelsbury is a small village on the north side of the Evenlode Valley. The photograph above, which was probably taken in the early 1950s, shows two rows of Cotswold-style cottages beside the B4026, which passes through the village and forms the main street. The picture below shows the same scene in 2012. Spelsbury church, on the west side of the village, is the burial place of John Wilmot (*see p. 5*), who died in 1680, aged just thirty-three; he has no memorial.

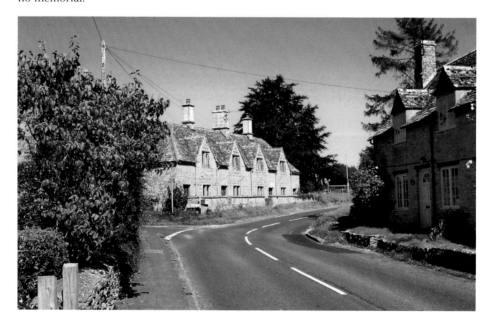

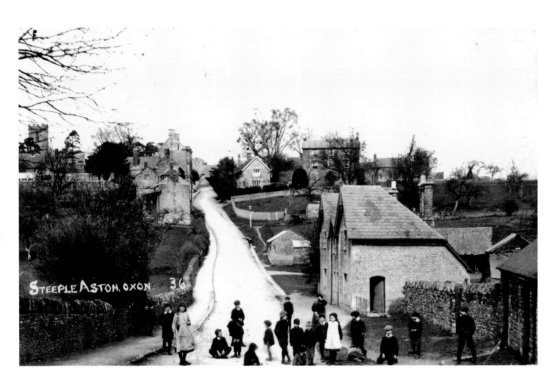

Steeple Aston: Paines Hill

Situated on high land about 10 miles to the south of Banbury, Steeple Aston straddles a steep-sided valley. The streets on either side are known as North Side and South Side, while Water Lane and Paines Hill provide north-to-south links between these two main streets. The picture above shows Paines Hill around 1912, and the recent colour view is from 2012. A considerable amount of 'infilling' has taken place, and there appear to be many more trees and bushes.

Steeple Aston: Old Building on North Side

(*Above*) Many of the buildings in Steeple Aston are built of an admixture of Oolitic limestone and brown ironstone – an example being Radcliffe's Almshouses in North Side Street, which date from the seventeenth century. (*Below*) The Grange, a little further to the west, is an eighteenth-century house, which was rebuilt in a bizarre style during the 1830s; it incorporates various constructional materials, including brick, stone and flintwork. The illustration is a sepia postcard of around 1912.

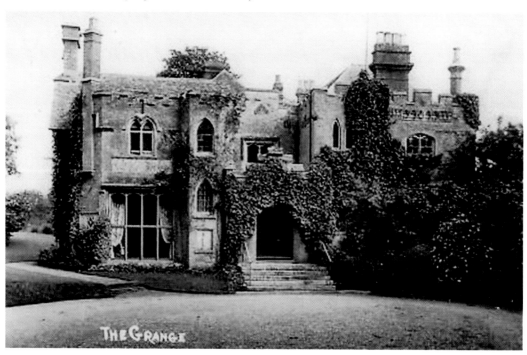

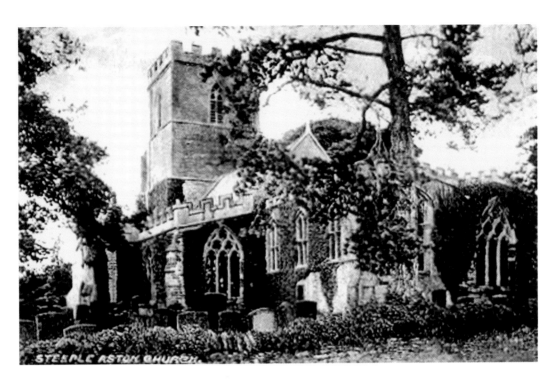

Steeple Aston: The Church of St Peter and St Paul

Steeple Aston parish church is a thirteenth-century building, which was remodelled during the fourteenth and fifteenth centuries, the porch, west tower and embattled parapets being of the Perpendicular period. The church contains an elaborate monument by the Flemish sculptor Peter Scheemakers to Sir Francis Page (c. 1660–1741), an alleged 'hanging judge' who resided at nearby Middle Aston. Intriguingly, Sir Francis seems to have been no harsher than other eighteenth-century judges; his notoriety was largely manufactured by Alexander Pope and other detractors.

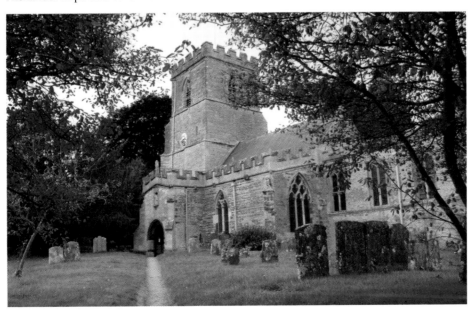

Steeple Aston: Paines Hill

Two additional views of Steeple Aston, both of which were taken in September 2012. The photograph above depicts a group of old houses on the west side of Paines Hill. The tall, Georgian-style house in the distance is particularly striking. Known as 'Paynes Hill House', it features a symmetrical façade with three-storey canted bay windows. The picture below, taken from a position further along the road, shows the junction with Cow Lane, which diverges to the right.

Tackley: The Green

Situated in the Cherwell Valley, about 12 miles south of Banbury and 9½ miles to the north of Oxford, Tackley is an archetypal, Cotswold-style village with a church, a manor house and many attractive old houses. Despite modern housing developments, the village has retained its rural atmosphere, as exemplified by these views of old buildings around the green. The photograph above dates from around 1964, while the colour view is from 2012.

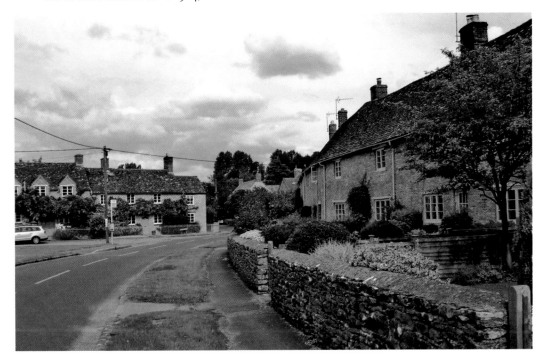

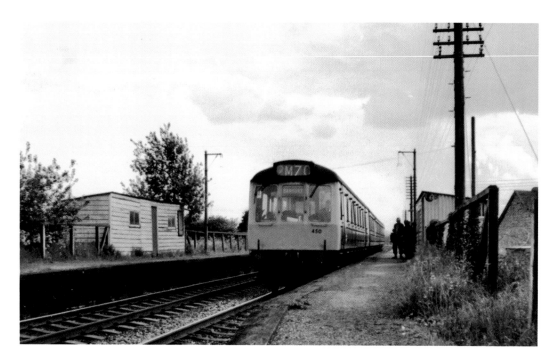

Tackley: The Railway Station

Tackley Halt was opened on 6 April 1931. Although designated a 'halt', Tackley was staffed by a female halt-keeper, who lived in a small cottage beside the railway line. Tackley has remained in operation as part of the national rail network, and in recent years it has generated around 19,000 passenger journeys per annum. The picture above shows the halt around 1970, looking south, while the recent view looks north towards Banbury.

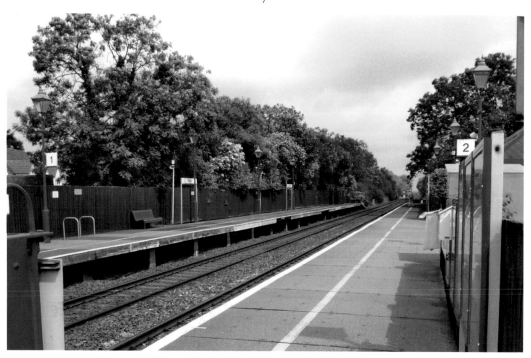

The Ford, Westcott Barton.

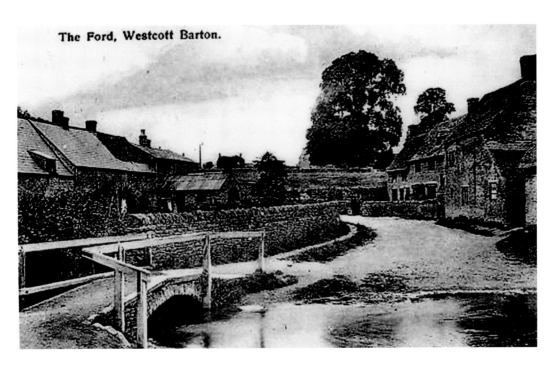

Westcot Barton: The Ford

Situated on either side of a little stream known as the River Dorn, Westcot Barton is an archetypal Cotswold village, with a medieval church and a Victorian manor house. Fox Lane, a straggling backstreet that leads down to a fording place on the river, has changed little over the years. The postcard view of the Ford, seen above, is from around 1912, while the lower view was photographed a century later in November 2012.

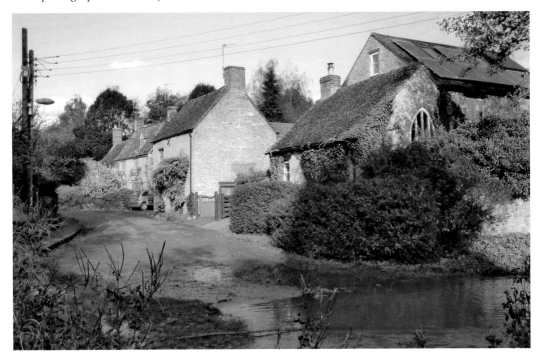

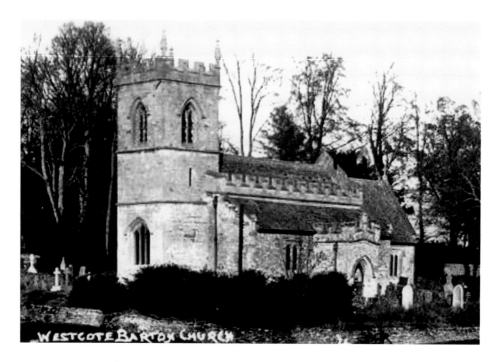

Westcot Barton: The Church of St Edward the Confessor

The parish church, comprising a nave, south aisle, chancel, porch and embattled west tower, contains some Norman fabric, including the south arcade, which has two round arches and a Romanesque pier. However, in architectural terms, the building belongs mainly to the fifteenth century – the embattled parapets and square-headed windows are typical of the Perpendicular period. The church is attractively situated at the west end of the village, on a hillside above the River Dorn.

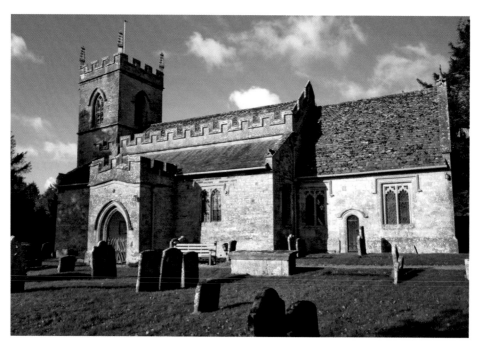

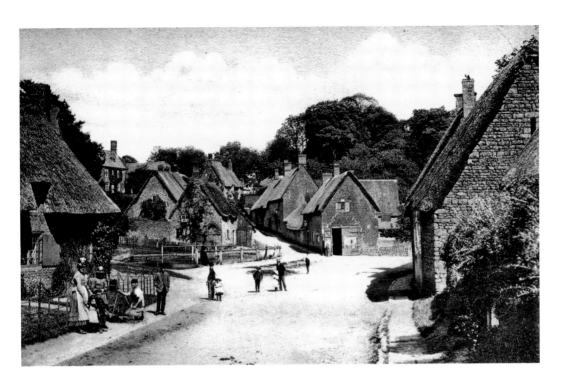

Wroxton: The Pond

Wroxton, to the north-west of Banbury, is a typical north Oxfordshire village, with a fine church and many old ironstone houses and cottages, together with a large and particularly impressive Jacobean mansion. The upper picture is looking eastwards along Main Street during the late Victorian period; the village pond can be seen to the left. The recent colour view was taken by Martin Loader from a similar vantage point near the pond.

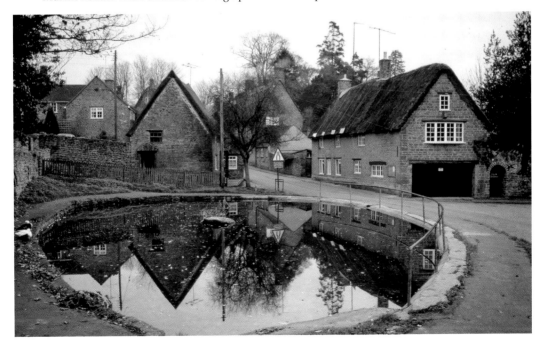

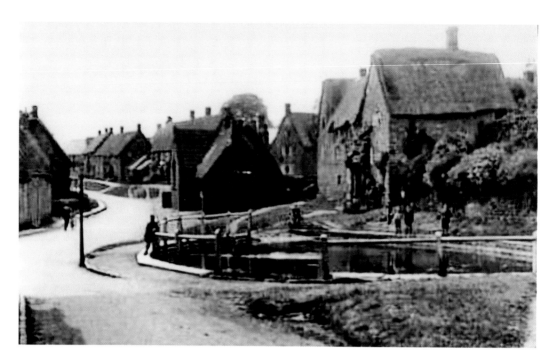

Wroxton: Main Street

This old sepia postcard view is looking westwards along Main Street, probably around 1910. The pond is a prominent feature in the foreground, while the post office can be seen in the distance. The colour view, which was taken from a position somewhat further along the street, shows the post office more clearly.

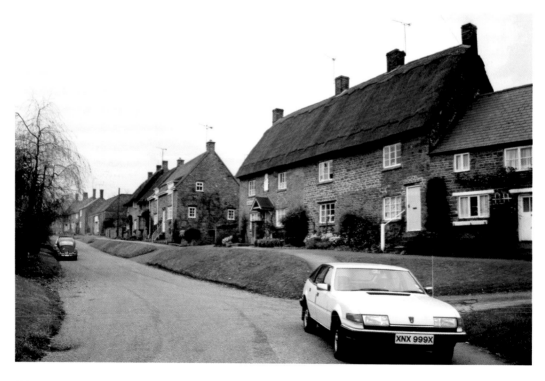

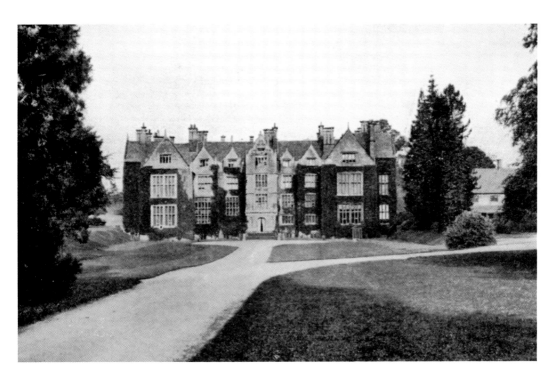

Wroxton Abbey

Wroxton Abbey, pictured above, is one of Oxfordshire's greatest Jacobean houses. It was built during the early seventeenth century by Sir William Pope (*c.* 1573–1631), the Earl of Downe, on the site of a former Augustinian priory. The property later passed, by marriage, to the North family – one of whom, Frederick North, had the misfortune to be Prime Minister during the disastrous American War of Independence. The house has now found a new role as an 'overseas campus' of Fairleigh Dickinson University, New Jersey. This colour postcard below was posted in 1923.

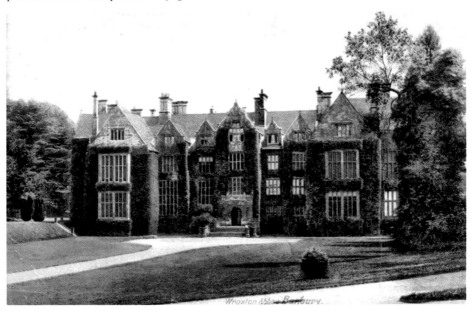

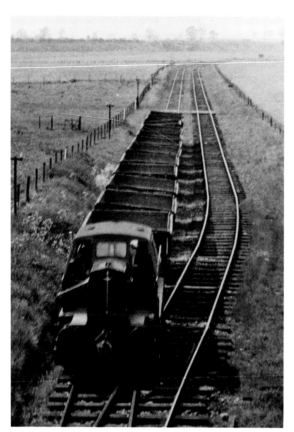

Wroxton: The Oxfordshire Ironstone Railway

Like Hook Norton, Wroxton was an ironstone mining village, quarries having been in operation in the area from 1917 until 1967. The quarry workings were served by an extensive private railway, known as the Oxfordshire Ironstone Railway, which ran westwards from the GWR main line near Banbury to the quarries around Wroxton and Hornton. The railway had its own workshops, signal boxes and other infrastructure, the main depot being sited near Wroxton. The illustration below shows the former locomotive sheds in 1970, by which time all of the trackwork had been removed. The photograph to the left, taken from a road overbridge around 1966, shows a Rolls-Royce Sentinel 0-4-0 diesel shunting locomotive known as *Barabel* at work on the ironstone railway. This locomotive was built at Shrewsbury in 1964, and she is now on the Nene Valley Railway in Northamptonshire.

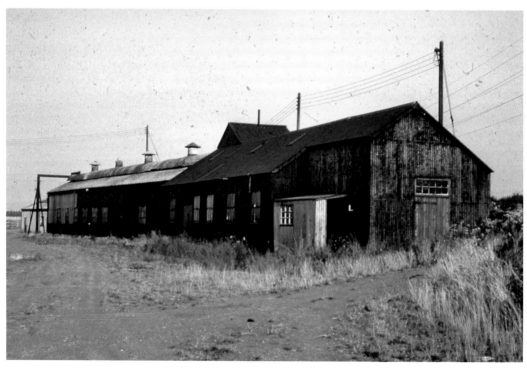

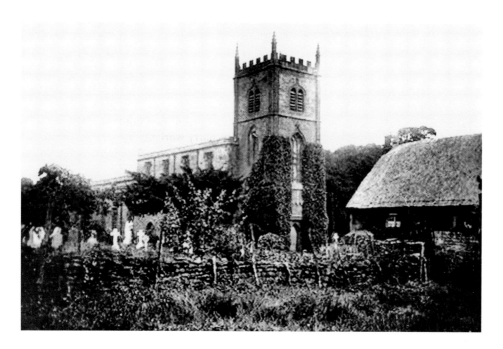

Wroxton: Village Scenes

All Saints church, which dates mainly from the fourteenth century, contains an elaborate tomb commemorating the Earl of Downe. Nearby, a simple stone marks the grave of Thomas Coutts (1735–1822), the immensely successful Scottish banker, who married a nursemaid and had three daughters: Susan, who married the 3rd Earl of Guilford; Frances, who married the first Marquis of Bute; and Sophia, who married the radical politician Sir Francis Burdett. The lower view shows the Wroxton Abbey entrance gates; the gentleman in the picture is Albert Loader, who was born in Wroxton in 1906.

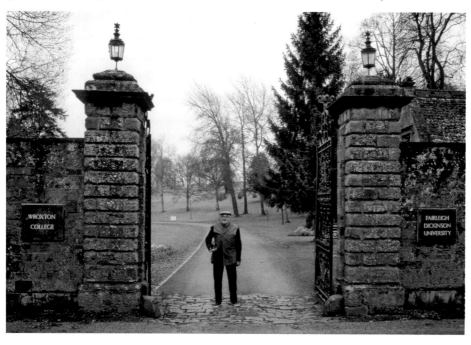

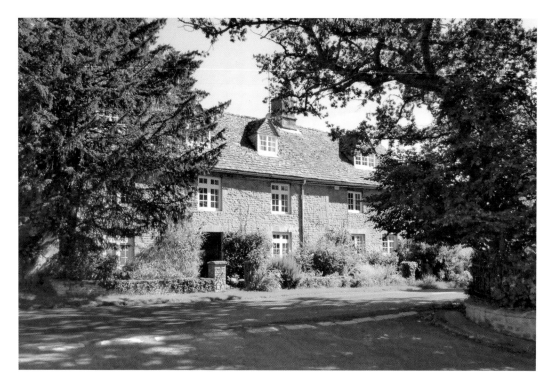

A Final Glimpse

These two final views exemplify the subtle differences that exist between the ironstone villages around Banbury and the Oolitic limestone villages further south. The picture above shows a row of Cotswold cottages in Spelsbury, and the very last view shows a picturesque thatched cottage in the ironstone village of Hook Norton.